The Artist's Painting Library

LANDSCAPES IN WATERCOLOR

BY WENDON BLAKE / PAINTINGS BY CLAUDE CRONEY

WATSON-GUPTILL PUBLICATIONS/NEW YORK

Copyright © 1979 by Billboard Ltd.

First published 1979 in the United States and Canada by Watson-Guptill Publications,
a division of Billboard Publications, Inc.,
1515 Broadway, New York, N.Y. 10036

Library of Congress Cataloging in Publication Data
Blake, Wendon.
 Landscapes in watercolor.
 (His The artist's painting library)
 Originally published as pt. 2 of the author's
The watercolor painting book.
 1. Water-color painting—Technique.
2. Landscape in art. I. Croney, Claude.
II. Title. III. Series.
ND2240.B57 1979 751.4'22 79-11816
ISBN 0-8230-2621-3

Manufactured in U.S.A.

First Printing, 1979

3 4 5 6 7 8 9/86 85 84 83

CONTENTS

Landscapes in Watercolor. Watercolorists paint more landscapes than any other subject. The transparency of watercolor makes the medium ideal for capturing luminous skies, the flicker of sunlight on a mass of leaves, and the crystalline shadows on a snowbank. The speed of watercolor is also a great advantage in painting outdoor subjects. As the clouds race by, as the sun moves across the sky and changes the pattern of light and shadow on those trees and snowbanks, you can capture these fleeting effects with a few bold washes and rapid brushstrokes. Speed means spontaneity: those fast, decisive strokes have a unique way of communicating the excitement of the subject and the artist's joy in painting.

Organization. You'll find that this text is organized in three sections. First, you'll find a brief review of the basic techniques of painting landscapes in watercolor. Then Claude Croney, a noted painter of outdoor subjects in watercolor, demonstrates ten complete paintings of popular landscape subjects, showing you how to put these techniques to work. Finally, there's a section on the special problems of planning and executing a successful landscape.

Wash Techniques. There are several basic ways of applying color to paper, as you may already know. The first section of *Landscapes in Watercolor* reviews these techniques by showing how they apply specifically to landscape subjects. The simplest method of applying color is a flat wash and you'll see how to use flat washes to build up the large, solid forms of mountains. Graded washes are just a bit more difficult, and you'll see how to paint a lake in this technique. Drybrush is a particularly good way to suggest textures, so you'll see how to paint rocks in the drybrush technique. Wet-in-wet—sometimes just called the wet-paper technique—is an effective way to create forms with soft, blurry edges; you'll see how to paint a misty landscape by this method. Of course, there's no "law" that mountains should always be painted in flat washes, lakes in graded washes, rocks in the drybrush technique, and mist in the wet-paper technique. You're free to use these methods according to your own tastes and according to the requirements of the subject. There will certainly be times when you'll want to paint mountains in graded washes, perhaps when the peaks are emerging from mist. Or you may want to use the drybrush technique to capture the broken light on the ripples of a lake. There are also many possible combinations of these techniques, such as establishing the basic form of a tree in flat washes, and then creating the textures of leaves and bark with drybrush.

Landscape Colors. Just before the actual painting demonstrations, you'll see a number of color sketches that will tell you more about the color you're likely to see outdoors. You'll see comparative studies of the colors of a clear sky and an overcast sky. You'll learn about the colors of trees, rocks, hills, and meadows. And you'll be able to compare the colors of a lake, a stream, and a pond filled with intricate reflections. There are also "life-size" close-ups of sections of various paintings by Claude Croney, showing how a professional watercolorist uses color to interpret the foliage of autumn and spring, the forms of green hills, and the patterns of moving water.

Painting Demonstrations. The purpose of the ten painting demonstrations is to allow you to study every significant painting operation step-by-step. Because a watercolor proceeds so quickly and decisions must be made without hesitation, it's important to plan the picture in logical stages. In these demonstrations, each stage is captured by the camera. Croney begins with three paintings of green, growing things: deciduous trees, evergreens, and a meadow filled with grasses, weeds, and wildflowers. He then goes on to paint the large, looming forms of mountains and the more modest forms of green hills. Water is particularly tricky to paint. Croney first shows how to paint the surface of a lake, with its complex pattern of ripples, reflections, lights and darks. He then goes on to show how to paint the action of a moving stream. Of course, snow and ice are both forms of water, so a separate demonstration is devoted to these wintry subjects. The painting demonstrations conclude with two skies: a blue, sunny sky with large, soft-edged clouds, and finally the ever-popular sunset.

Special Problems. The final section begins by advising you how to select an appropriate subject for a landscape painting, which most beginners find particularly difficult. There are also some guidelines—some dos and some don'ts—for composing landscape paintings. You'll see how lighting affects various landscape subjects and how changes in the light actually change the landscape itself. You'll learn how to exploit the effects of aerial perspective to create a sense of deep space in a landscape. "Life-size" close-ups of Claude Croney's paintings will show you how to wield the brush expressively. To encourage you to study the varied forms of the natural landscape, there are studies of different kinds of rock, tree, and cloud forms. Finally, you'll learn the "three-value system," a very simple, time-tested method of designing a successful landscape.

Tubes and Pans. Watercolors are normally sold in collapsible metal tubes about as long as your thumb, and in metal or plastic pans about the size of the first joint of your thumb. The tube color is a moist paste that you squeeze out onto the surface of your palette. The color in the pan is dry to the touch, but dissolves as soon as you touch it with a wet brush. The pans, which lock neatly into a small metal box made to fit them, are convenient for rapid painting on location. But the pans are useful mainly for small pictures—no more than twice the size of this page—because the dry paint in the pans is best for mixing small quantities of color. The tubes are more versatile and more popular. The moist color in the tubes will quickly yield small washes for small pictures and big washes for big pictures. If you must choose between tubes and pans, buy the tubes. Later, if you want a special kit for painting small pictures outdoors, buy the pans.

Color Selection. All the pictures in this book were painted with just eleven tube colors. True, the colors of nature are infinite, but most professional watercolorists find that they can cope with the colors of nature with a dozen tube colors—or even less. Once you learn to mix the various colors on your palette, you'll be astonished at the range of colors you can produce. Six of these eleven colors are *primaries*—two blues, two reds, two yellows—which means colors that you can't create by mixing two primaries. Just two are *secondaries*—orange and green—which means colors that you *can* create by mixing other colors. You can mix a rich variety of greens by combining various blues and yellows, plus many different oranges by combining reds and yellows. So you could really do without the secondaries. But it does save time to have them. The last three colors on your palette are what painters call neutrals: two shades of brown and a gray.

Blues. Ultramarine is a dark, soft blue that produces a rich variety of greens when blended with the yellows, and a wide range of grays, browns, and brown-grays when mixed with the neutrals. Cerulean blue is a light, bright blue that is popular for skies and atmospheric effects. At some point in the future, you might like to try substituting phthalocyanine blue for cerulean; phthalocyanine is more brilliant, but must be used in small quantities because it tends to dominate any mixture.

Reds. Alizarin crimson is a bright red with a hint of purple; it produces lovely oranges when mixed with the yellows, subtle violets when mixed with the blues, and rich darks when mixed with green. Cadmium red light is a dazzling red with a hint of orange, producing rich oranges when mixed with the yellows, coppery tones when mixed with the browns, and surprising darks (not violets) when mixed with the blues.

Yellows. Cadmium yellow light is bright and sunny, producing luminous oranges when mixed with the reds, and rich greens when mixed with the blues. Yellow ochre is a much more subdued, tannish yellow that produces subtle greens when mixed with the blues, and muted oranges when mixed with the reds. You'll find that both cadmiums tend to dominate mixtures, so add them just a bit at a time.

Orange. Cadmium orange is a color you really could create by mixing cadmium yellow light and cadmium red light. But it's a beautiful, sunny orange and convenient to have ready-made.

Green. Hooker's green is optional—you can mix lots of greens—but convenient, like cadmium orange. Just don't become dependent on this one green. Learn how many other greens you can mix by combining your various blues and yellows. And see how many other greens you can make by modifying Hooker's green with the other colors on your palette.

Browns. Burnt umber is a dark, subdued brown that produces lovely brown-grays and blue-grays when blended with the blues, subtle foliage colors when mixed with green, and warm autumn colors when mixed with reds, yellows, and oranges. Burnt sienna is a bright, orange-brown that produces a very different range of blue-grays and brown-grays when mixed with the blues, plus rich coppery tones when blended with reds and yellows.

Gray. Payne's gray has a distinctly bluish tone, which makes it popular for painting skies, clouds, and atmospheric effects.

No Black, No White. You may be surprised to discover that this color list contains no black or white. Once you begin to experiment with color mixing, you'll find that you don't really need black. You can mix much more interesting darks—containing a fascinating hint of color—by blending such colors as blue and brown, red and green, orange and blue. And blue-brown mixtures make far more interesting grays than you can create with black. You sheet of watercolor paper provides the only white you need. You lighten a color mixture with water, not with white paint; the white paper shines through the transparent color, "mixing" with the color to produce the exact shade you want. If some area is meant to be *pure* white, you simply leave the paper bare.

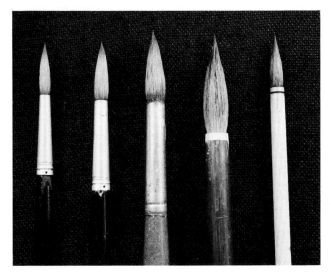

Round Brushes. When wet, a round brush should have a neat bullet shape and come to a sharp point. Here are five typical round brushes. The two at left are expensive sables. The center brush is a less expensive oxhair. At right are two inexpensive oriental brushes with bamboo handles—worth trying if you're on a tight budget. A good substitute for sable is soft white nylon.

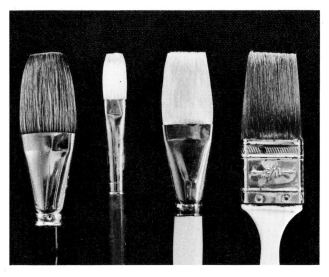

Flat Brushes. A good flat brush, when wet, should taper to a squarish shape that curves inward toward the working end. Here, from left to right, are a large oxhair, good for big washes; a small bristle brush like those used for oil painting, helpful for scrubbing out areas to be corrected; a large white nylon brush, a good substitute for the more expensive sable; and a nylon housepainter's brush, which you might like to try for painting or wetting big areas.

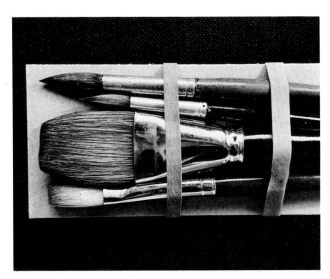

Transporting Brushes. When you're carrying your brushes from place to place, it's important to protect the delicate hairs from being squashed in your paintbox. You can cut a piece of cardboard that't just a bit longer than the longest brush; arrange the brushes carefully on the board so that they don't squash each other; then strap them down with rubber bands. For further protection, you can slip the board into a sturdy envelope or wrap it in something flexible such as a cloth or bamboo placemat secured with a couple of rubber bands.

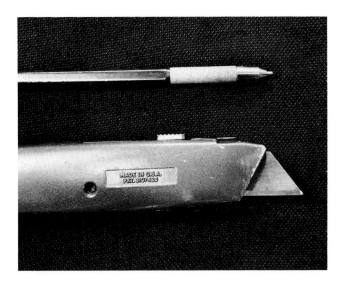

Pencil and Knife. To sketch your composition on the watercolor paper, carry a sharp pencil with a lead that's not too dark. HB is a good grade. A mechanical pencil with retractable lead is least apt to break. For cutting paper and tape, as well as for scratching lines into your painting, a sharp knife is handy. This knife is convenient and safe because it has a retractable blade, which you replace when it gets dull.

Watercolor Palette. The most versatile type of water-color palette is made of white molded plastic or lightweight metal coated with tough white enamel paint. Along the edges of this white plastic palette are compartments into which you squeeze your tube colors. The center of the palette is a large, flat mixing area. A "lip" prevents the tube colors from running out of the compartments into the central mixing area. At the end of the painting session, you can simply mop up the mixing area with a sponge or paper towel, leaving the color in the compartments for the next session.

Studio Palette. Designed primarily for use indoors, this palette has circular "wells" into which you squeeze your tube colors, plus rectangular compartments for individual mixtures. The compartments slant down at one end so that the mixtures will run downward and form pools into which you can dip your brush.

Fiberboard and Tacks. A simple way to support your watercolor paper when you're painting is to tack the sheet to a stiff piece of fiberboard. This particular piece of fiber-board is 3/4″ (about 18 mm) thick and soft enough to accept thumbtacks (drawing pins) or pushpins. Be sure to cut the board just a bit larger than the size of your watercolor paper.

Plywood and Tape. Another solution is to tape your wa-tercolor paper to a sheet of wood—preferably plywood, which will resist warping when it gets wet. The wood will be too hard to take tacks, so use masking tape that's at least 1″ (25 mm) wide or even wider if you can find it. A sheet of smooth hardboard will also do the job. If available, buy hardboard or plywood that's made for outdoor use; it's more resistant to moisture.

Step 1. Mountains are a good subject for practicing flat washes. The big shapes are blocked in with a series of strokes, slightly overlapping one another so they fuse together at the edges. The tone doesn't have to be smooth and even; mountains are craggy, after all, and the individual strokes can show a bit.

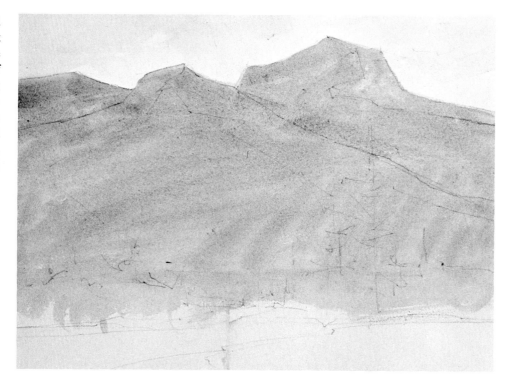

Step 2. For the shadow sides of the mountain, a darker wash is applied with free, irregular strokes. These big planes of light and shadow can be painted very effectively with a flat brush.

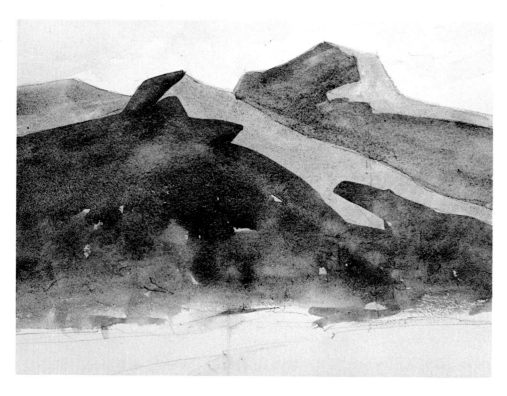

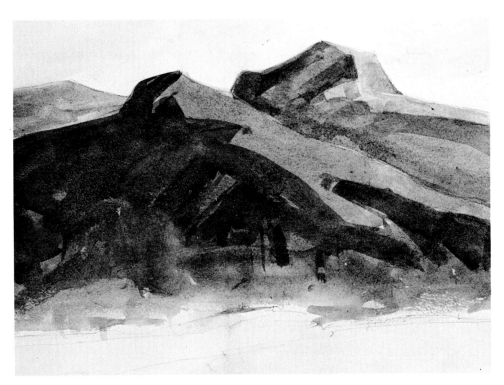

Step 3. When that shadow plane is dry, darker shadow tone is applied to strengthen and vary that section. The shadow tone that was painted in Step 2 isn't completely covered here, but peeks through the darker tone to suggest a variety of lights and shadows.

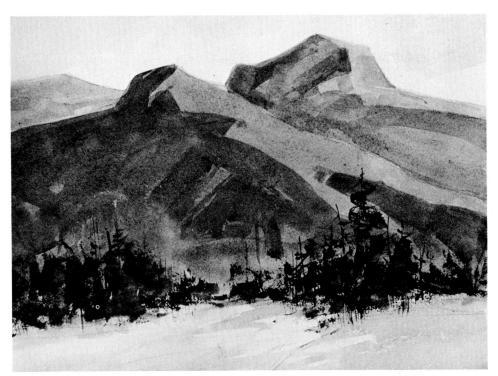

Step 4. With the light and shadow planes of the mountains completed, still darker tone is mixed for the trees in the foreground. These are brushed in with quick, irregular strokes, made by the tip of a small, round brush. To suggest snow beneath the trees, some pale strokes are added—about as dark as the wash in Step 1. The whole picture is painted in four flat tones.

Step 1. This atmospheric study of a lake begins with a wash that goes from dark to light to dark again. The sky at the top begins with some dark strokes, followed by paler strokes that blend with the dark ones and work down to the midpoint of the sheet. Then these pale strokes begin to fuse with darker strokes once again, coming down to the edge of the lake.

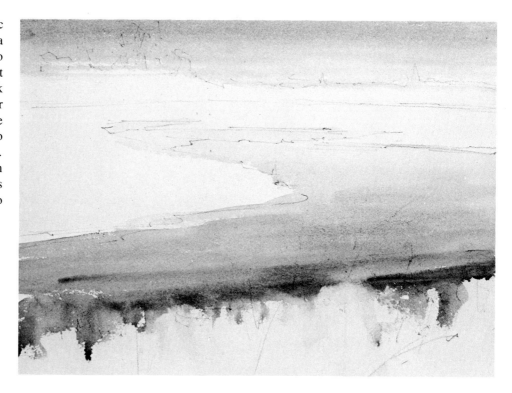

Step 2. The land mass below the sky is also a kind of graded wash, starting with dark strokes at the horizon and then gradually giving way to paler strokes in the wedge of shore at the left. The foreground grasses are roughly indicated with pale vertical strokes.

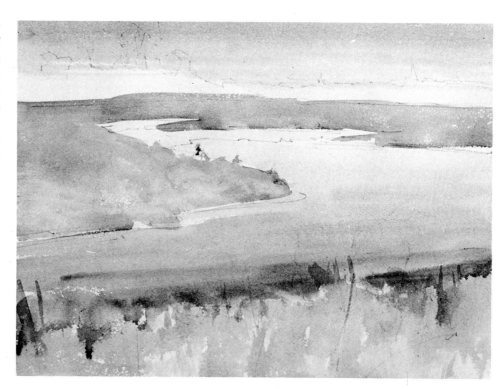

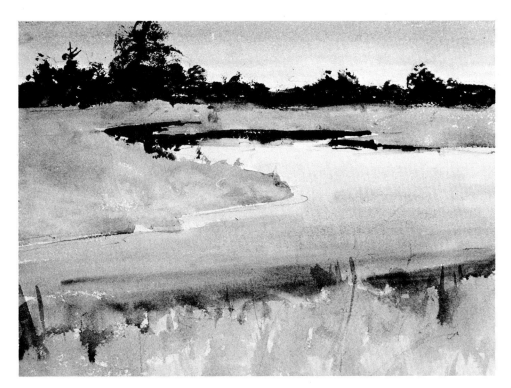

Step 3. When the darks of the trees are blocked in at the horizon, the graded wash in the sky suddenly creates a feeling of glowing light. And when the dark reflection of the trees is added just below the distant shore, the graded wash of the lake gives the impression of reflected light on the distant water.

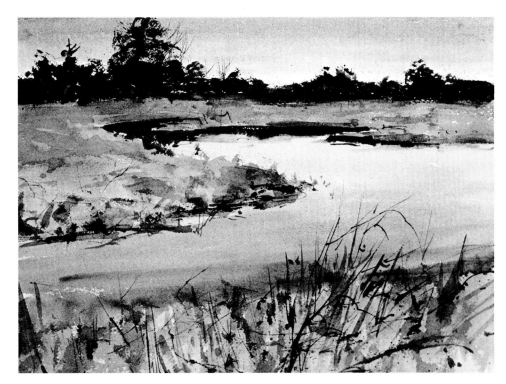

Step 4. Now the picture is completed by adding some darks along the edge of the near shoreline and adding some strokes for weeds in the immediate foreground. The graded wash in Step 1 doesn't make much sense all by itself; but with these details added, the sky and water glow with light.

Step 1. Now let's see how a rock formation is painted in drybrush. The distant landscape is painted in several flat washes. The sky is one irregular flat wash with some darker strokes added, wet-in-wet. The scrubby tree is painted by pressing down a damp brush and pulling it away. Now the drybrush work begins.

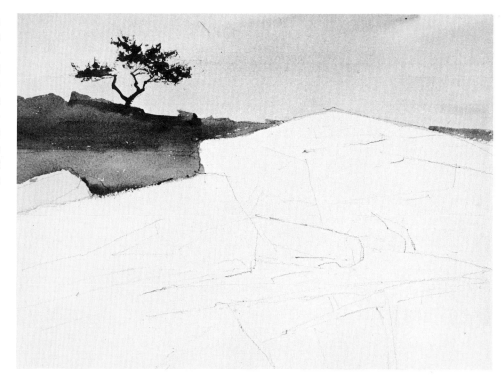

Step 2. The shadows on the rocks are painted with the quick strokes of a damp, flat brush held at an angle so the flat side hits the paper. The lighted tops of the rocks are textured by very light strokes of the brush, applied with very little pressure, and pulled along rapidly, just skimming the surface of the paper.

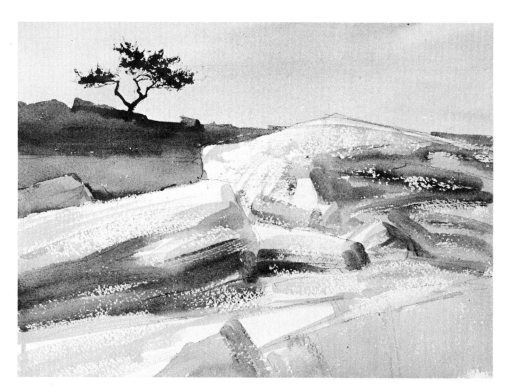

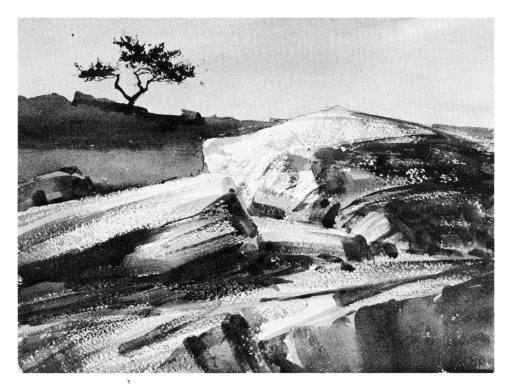

Step 3. The shadow sides of the rocks are darkened with further drybrush strokes. This time, the color on the brush is not only darker, but a bit wetter. And the brush is pressed harder against the paper, forcing the color further into the valleys. The slender strokes are made with a round brush. And the shadow in the lower right corner is a fluid, flat wash.

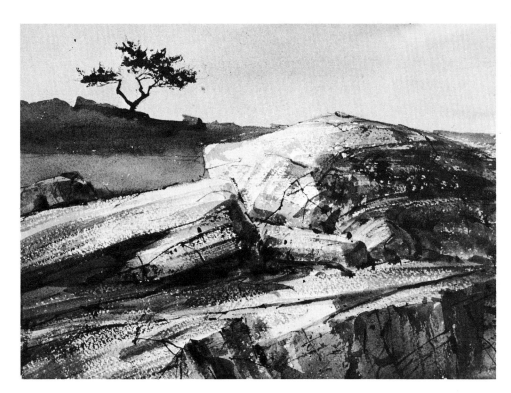

Step 4. More drybrush textures are added to the shadow on the lower right. Then the tip of a small, round brush is used to strike in slender lines for the cracks and flecks that complete the rocks.

Step 1. It's usually best to *begin* with a wet-in-wet effect and then complete the painting with strokes and washes on dry paper. In this first stage, the entire sheet is brushed with clear water. Then the distant shore, the island, and the ripples in the water are all painted into this wet surface and allowed to dry. The dark strokes are thicker color, diluted with less water.

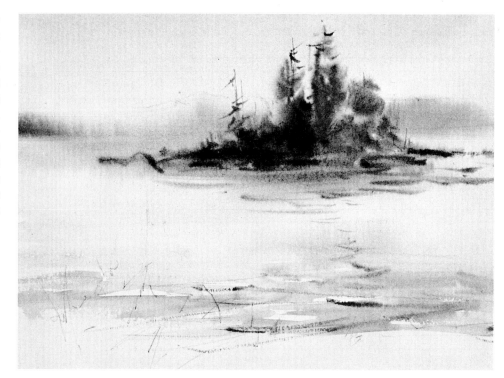

Step 2. The entire sheet is allowed to dry. Then the foreground is begun with free strokes, scraped here and there with the tip of the brush handle suggesting weeds struck by the light.

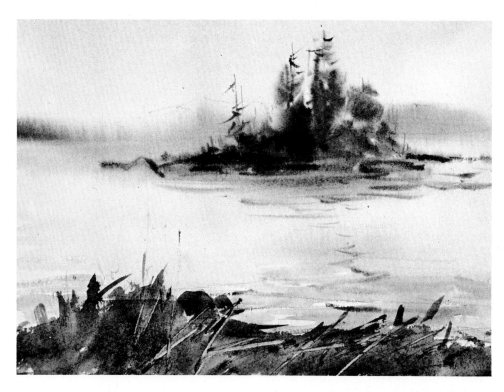

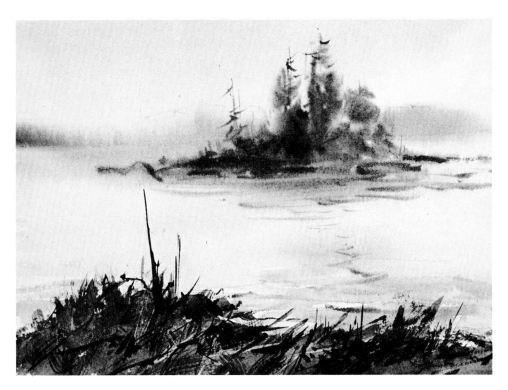

Step 3. The foreground is gradually built up with more and more crisp, dark strokes working their way across the misty blur of the lake. The contrast of the sharp focus foreground and the blurry distance is the key to the picture—the foreground makes the wet-in-wet island look more distant and mysterious.

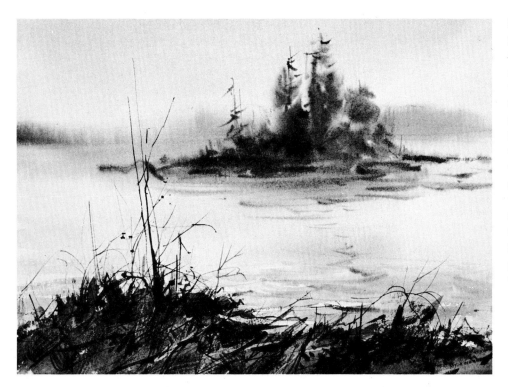

Step 4. The weeds of the foreground are completed with long, slender strokes that cut across the blurred, wet-in-wet distance, further accentuating the contrast between sharp focus and soft focus. At this point, it's possible to re-wet certain areas of the island with clear water and drop in additional dark touches, which are almost invisible because they blur away into the surrounding darkness. But do this very selectively and with great care—don't rewet the whole painting.

Studio Setup. Whether you work in a special room you've set aside as a studio, or just in a corner of a bedroom or a kitchen, it's important to be methodical about setting up your painting equipment. Let's review the basic equipment you'll need and let's see how this equipment should be arranged.

Brushes. It's best to buy just a few brushes—and buy the best you can afford. You can perform every significant painting operation with just four softhair brushes, whether they're expensive sable, less costly oxhair or squirrel, soft white nylon, or some blend of inexpensive animal hairs. All you really need are a big number 12 round and smaller number 7 round plus a big 1″ (25 mm) flat and a second flat about half that size.

Paper. The best all-purpose watercolor paper is mouldmade 140 pound stock in the cold pressed surface (called a "not" surface in Britain) which you ought to buy in the largest available sheets and cut into halves or quarters. The most common sheet size is 22″ x 30″ (56 cm x 76 cm). Later, you may want to try the same paper in a rough surface.

Drawing Board. The simplest way to support your paper while you work is to tack or tape the sheet to a piece of hardboard, cut just a little bigger than a full sheet or half sheet of watercolor paper. You can rest this board on a tabletop, perhaps propped up by a book at the back edge, so the board slants toward you. You can also rest the board in your lap or even on the ground. Art supply stores carry more expensive wooden drawing boards to which you tape your paper. At some point, you may want to invest in a professional drawing table, with a top that tilts to whatever angle you find convenient. But you can easily get by with an inexpensive piece of hardboard, a handful of thumbtacks or pushpins, and a roll of masking tape, 1″ (25 mm) wide to hold down the edges of your paper.

Palette or Paintbox. Some professionals just squeeze out and mix their colors on a white enamel tray—which you can probably find in a shop that sells kitchen supplies. The palette made *specifically* for watercolor is white metal or plastic, with compartments into which you squeeze tube colors, plus a mixing surface for producing quantities of liquid color. For working on location, it's convenient to have a metal watercolor box with compartments for your gear. But a toolbox or a fishing tackle box—with lots of compartments—will do just as well. If you decide to work outdoors with pans of color, buy an empty metal box

equipped to hold pans, then buy the selection of colors listed in this book: don't buy a box that contains pans of color preselected by the manufacturer.

Odds and Ends. You'll need some single-edge razor blades or a knife with a retractable blade (for safety) to cut paper. Paper towels and cleansing tissues are useful, not only for cleaning up, but for lifting wet color from a painting in progress. A sponge is excellent for wetting paper, lifting wet color, and cleaning up spills. You'll obviously need a pencil for sketching your composition on the watercolor paper before you paint: buy an HB drawing pencil in an art supply store or just use an ordinary office pencil. To erase the pencil lines when the watercolor is dry, get a kneaded rubber (or "putty rubber") eraser, so soft that you can shape it like clay and erase a pencil line without abrading the delicate surface of the paper. Find three wide-mouthed glass jars big enough to hold a quart or a liter of water; you'll find out why in a moment. If you're working outdoors, a folding stool is a convenience—and insect repellent is a *must*!

Work Layout. Lay out your supplies and equipment in a consistent way, so everything is always in its place when you reach for it. Directly in front of you is your drawing board with your paper tacked or taped to it. If you're right-handed, place your palette and those three wide-mouthed jars to the right of the drawing board. In one jar, store your brushes, hair end up; don't let them roll around on the table and get squashed. Fill the other two jars with clear water. Use one jar of water as a "well" from which you draw water to mix with your colors; use the other for washing your brushes. Keep the sponge in a corner of your palette and the paper towels nearby, ready for emergencies. Line up your tubes of color some place where you can get at them quickly—possibly along the other side of your drawing board—when you need to refill your palette. Naturally, you'd reverse these arrangements if you're left-handed.

Palette Layout. In the excitement of painting, it's essential to dart your brush at the right color instinctively. So establish a fixed location for each color on your palette. There's no one standard arrangement. One good way is to line up your colors in a row with the *cool* colors at one end and the *warm* colors at the other. The cool colors would be gray, two blues, and green, followed by the warm yellows, orange, reds, and browns. The main thing is to be consistent, so you can find your colors when you want them.

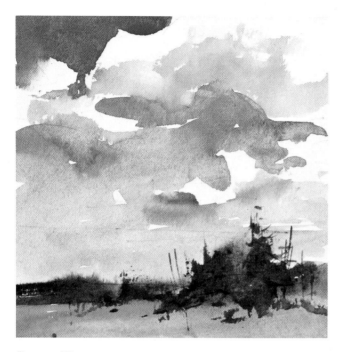

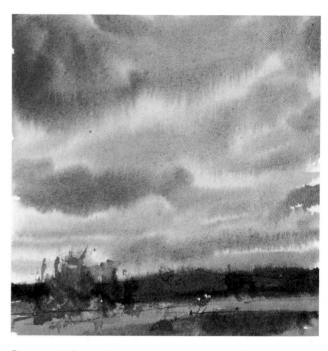

Sunny Sky. On a sunny day, the sky is usually bluest at the top, paler and warmer at the horizon. Here, the deeper blues are a mixture of ultramarine blue and cerulean blue. Lower down, the paler, warmer tone is a mixture of cerulean blue, yellow ochre, and alizarin crimson. The shadow sides of the clouds are Payne's gray and yellow ochre. The lighted sides are bare paper.

Overcast Sky. An overcast sky isn't always steely gray, but often has a warm tone because the sun is trying to force its way through the clouds. These clouds, painted on wet paper, are a mixture of Payne's gray, yellow ochre, and burnt umber. There are touches of cerulean blue where the sky appears through the clouds.

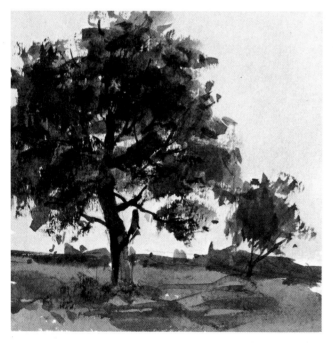

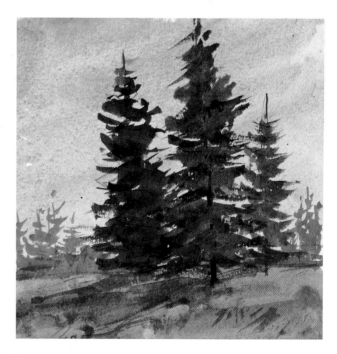

Deciduous Trees. The sunlit patches of leaves are a mixture of Hooker's green, burnt sienna, and burnt umber, dominated by the green. The shadow areas are the same mixture, with more burnt sienna and burnt umber. The grass is Hooker's green, cadmium yellow, and burnt sienna, with more green and brown in the shadows.

Evergreens. On the foreground trees, the lighter areas are Hooker's green, cadmium yellow, and burnt sienna, while the darker areas are Hooker's green, burnt umber, and ultramarine blue. The distant trees are a pale mixture of Hooker's green, burnt sienna, and ultramarine blue. The grass is cadmium yellow, Hooker's green, and cerulean blue, with more blue in the shadows.

Rocks. Avoid the temptation to paint rocks as if they're all gray or brown. They contain many subtle colors. The shadow sides of these rocks are built up with multiple strokes in various combinations of yellow ochre, burnt sienna, burnt umber, and cerulean blue. The lighted sides are bare paper with touches of yellow ochre, burnt sienna, and cerulean blue. The distant mountains, which are really paler, cooler versions of the nearby rocks, are painted in burnt sienna and cerulean blue. The dried grass in the field contains various mixtures of yellow ochre, burnt sienna, cerulean blue, and cadmium orange.

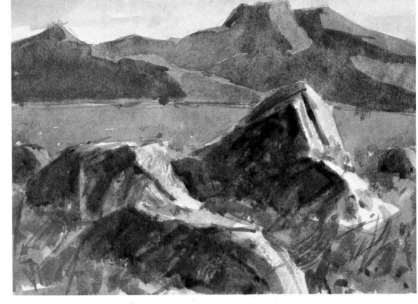

Hills. Hills covered with foliage aren't a uniform green, but contain various warm and cool colors. The underlying tone of the hills is a mixture of Hooker's green, ultramarine blue, and burnt sienna, with more burnt sienna to the left and more Hooker's green to the right. The tree strokes are various mixtures of Hooker's green, ultramarine blue, and burnt sienna. The field in the foreground is cadmium yellow, Hooker's green, and burnt sienna, with more burnt sienna to the left and more Hooker's green to the right.

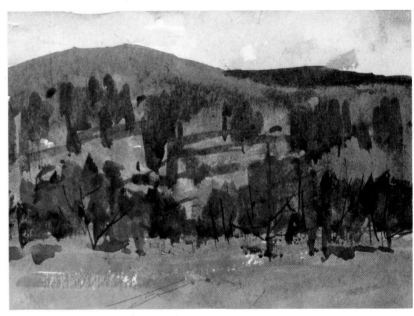

Meadow. A meadow can be a rich tapestry of cool greens and warm yellows, oranges, and browns. This field was painted with various mixtures of cerulean blue, Hooker's green, cadmium yellow, yellow ochre, and burnt sienna. Hooker's green and the yellows dominate the distance, while the foreground contains both yellows and much more burnt sienna. The trees along the horizon are overlapping strokes, containing various combinations of Hooker's green, burnt umber, cerulean blue, and ultramarine blue.

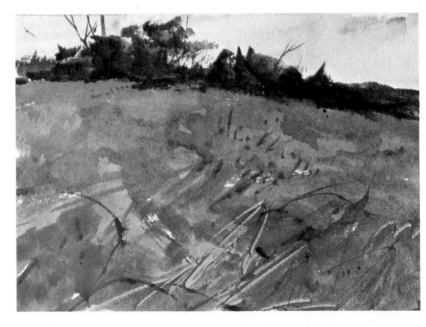

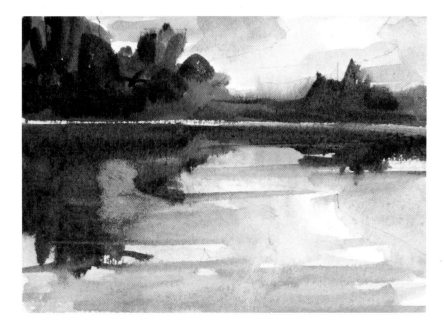

Lake. Clear water has no color of its own, but simply reflects the colors that surround it. This calm lake acts as a mirror for the colors of the sky and the shoreline. The sky is cerulean blue and yellow ochre. The trees along the shore are various combinations of Hooker's green, cadmium yellow, burnt sienna, and ultramarine blue. The same color combinations appear in the water.

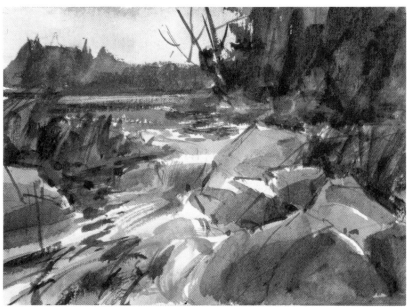

Stream. Although moving water may be interrupted by a broken pattern of lights and shadows, it's still a reflecting surface. Here, the sky is cerulean blue and a touch of yellow ochre, reflected in the cool areas of the stream. The rocks are ultramarine blue, burnt umber, and yellow ochre—a combination that is reflected in the warmer areas of the stream. The distant trees along the horizon are Hooker's green, ultramarine blue, and burnt sienna, reflected in the water at upper left.

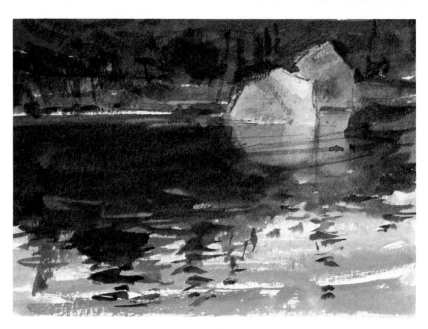

Reflections. In this close-up, you can see how the water reflects the colors of the foliage along the shore, the rocks, and the sky. The greens along the shore and in the water are Hooker's green, burnt sienna, and ultramarine blue. The rocks are yellow ochre, burnt sienna, and ultramarine blue, with the same combination in their reflections, slightly cooled by Hooker's green. Although you can't see the sky, you know that it's reflected in the blue of the water, which is cerulean blue and a little yellow ochre.

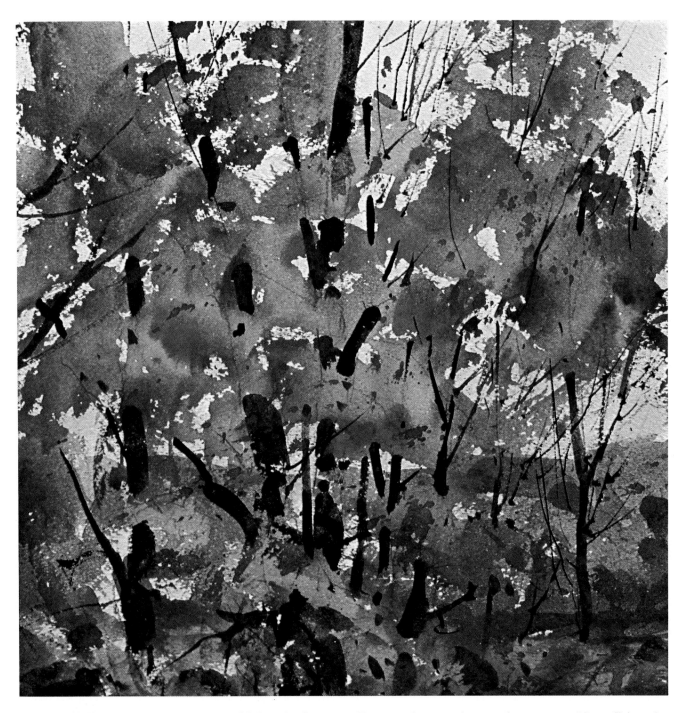

Autumn Foliage. These lively masses of foliage begin as broad strokes of a fairly light tone—various mixtures of yellow ochre, cadmium yellow, cadmium red, burnt sienna, and Hooker's green, with plenty of water. Then, while these strokes are still very wet, stronger colors are quickly dabbed in, blurring into the underlying tone. You can see where strokes of much hotter colors—burnt sienna, cadmium red, and cadmium yellow—merge with the underlying wash.

You can also see where cooler tones are "floated" into the underlying wash—mixtures dominated by Hooker's green but also containing small quantities of reds and yellows. For the big, broad strokes, a very wet brush is pressed firmly against the paper. Around these broad strokes, a damp brush is skimmed lightly over the paper to create drybrush effects that suggest leaves. The trunks are short, firm strokes of wet color.

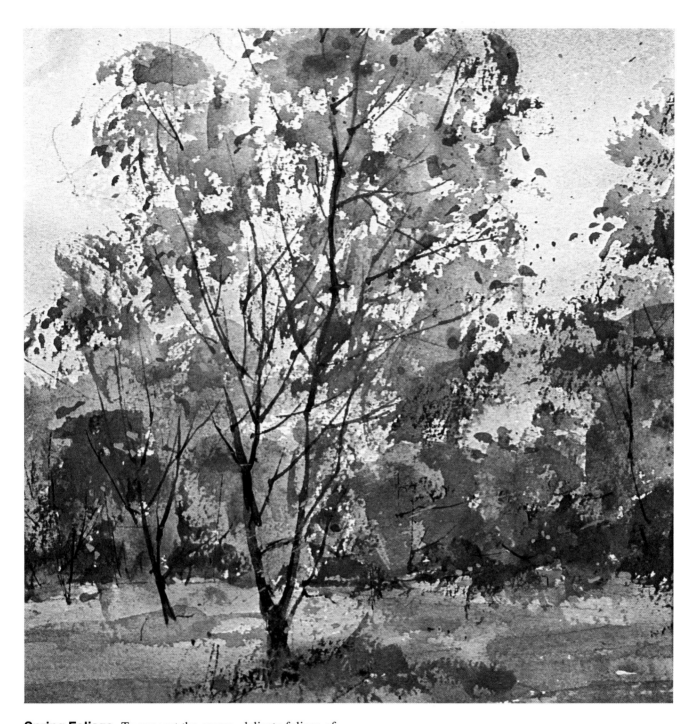

Spring Foliage. To suggest the sparse, delicate foliage of spring—before the trees are covered with heavy masses of leaves—the brush carries plenty of wet color, but *doesn't* make big, solid strokes. The brush moves gently over the surface of the paper, sometimes pressing down and sometimes just skimming. Thus, you see smaller, more irregular masses of color and lots of drybrush areas, where the brush just touches the peaks and skips over the valleys of the painting surface. Around the edges of the trees, the tip of a small brush is used to suggest a few leaves here and there. The more distant trees are painted with somewhat broader, more solid strokes, but they still contain a good deal of drybrush. To create these very delicate textures and broken strokes, try working with the side of the brush.

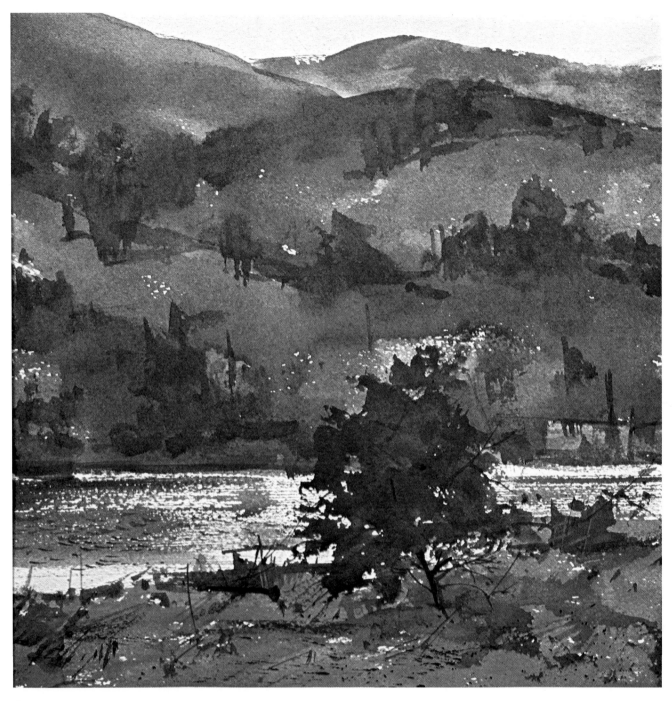

Green Hills. The distant hills are first painted with broad sweeps of a large brush carrying lots of liquid color. Then, just before this underlying wash dries—while it still has a slight shine—smaller, darker strokes are added to suggest trees. Additional tree strokes are painted in when the surface is completely dry. You can see that the earlier tree strokes tend to fuse with the underlying color of the hills, while the later strokes are quite distinct and have much more sharply defined edges. The foreground tree is painted with a very wet brush, but the strokes are ragged and have a drybrush feeling because the side of the brush is used to deposit the color.

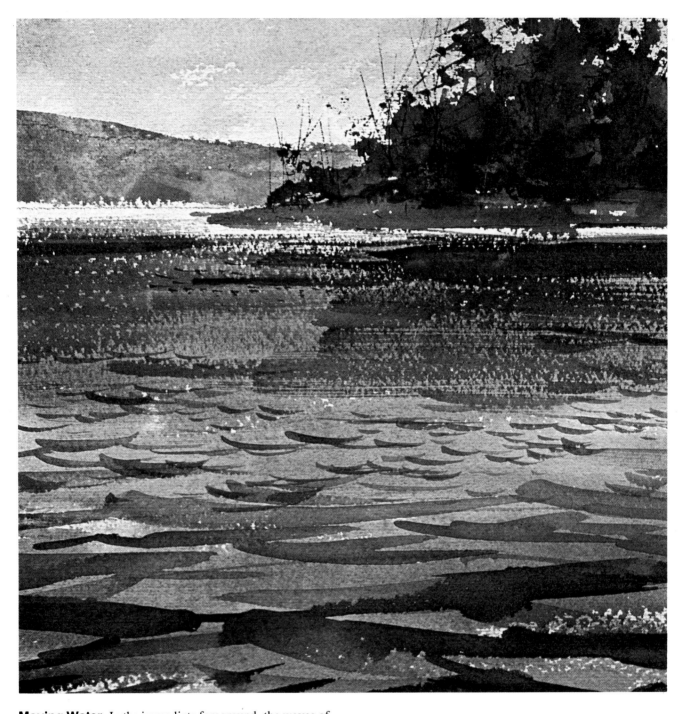

Moving Water. In the immediate foreground, the waves of moving water are rendered with the big, long strokes of a large, very wet brush. In the middle distance, these strokes gradually become shorter and thinner—applied with the tip of the big brush or with a small brush. Above the midpoint of the picture, individual strokes disappear, and you can no longer see each ripple. Instead, you see long, horizontal drybrush strokes, made with a damp brush that simply skims along the surface of the paper. The broken texture of these strokes suggests the movement of the water and the flickering light on the ripples. Just a few dark ripples are picked out with the point of a very small brush, below the tip of the island. Along the horizon, the flash of light on the water is bare paper, with just a few very pale, horizontal drybrush strokes.

Step 1. The pencil drawing clearly defines the individual masses of foliage and the trunks of the trees to the left and indicates the general shapes of the trees along the horizon. The sky begins as a pale wash of yellow ochre into which pale strokes of cerulean blue are painted.

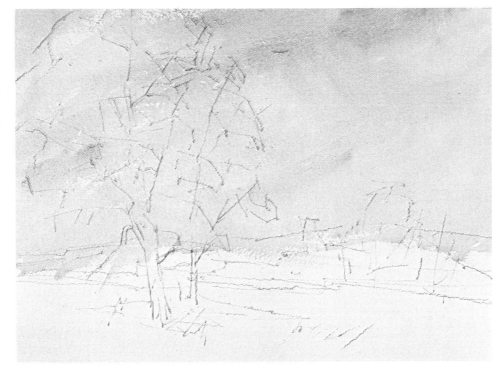

Step 2. The distant hills, which you can see clearly to the left, are painted with cerulean blue and cadmium red. While this tone is still wet, the trees are brushed in with Hooker's green and burnt sienna, blurring into the color of the hills.

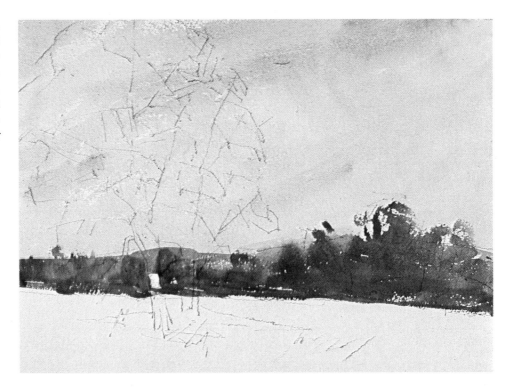

Step 3. The field is covered with a light wash of yellow ochre and Hooker's green, followed by darker strokes of this mixture, some containing a hint of burnt sienna and others containing just a bit of ultramarine blue. Some of these darker strokes go on while the underlying wash is still wet. Others are applied after the surface is dry.

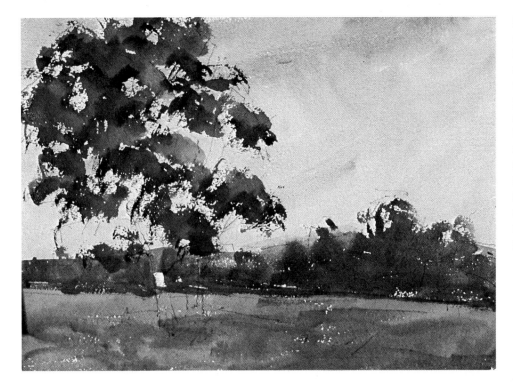

Step 4. The lighter, brighter areas of the foliage are brushed in with broad, short, curving strokes—in various combinations of cadmium yellow, yellow ochre, Hooker's green, and ultramarine blue. While these lighter strokes are still wet, the darks are brushed over and into them, so the darks and lights tend to blur together. The darks are Hooker's green, ultramarine blue, and burnt sienna.

Step 5. So far, everything has been done with big brushes. Now, a small, round brush comes into play. The trunks are painted with a dark mixture of Hooker's green and alizarin crimson. The very tip of the brush is used to paint the branches with the same mixture. At times, the brush skims very lightly over the surface of the paper so that the strokes have a dry-brush feeling.

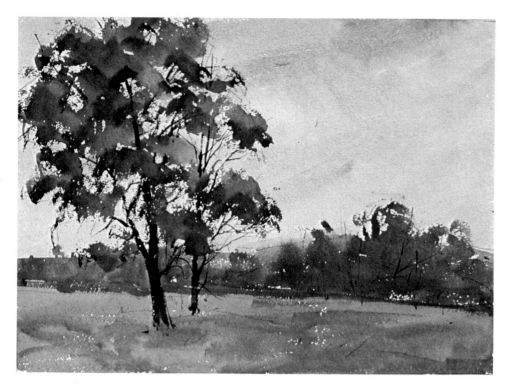

Step 6. More dark notes are added to the tree with a mixture of Hooker's green and burnt umber. The small brush is used again—often held so that the side of the brush leaves irregular patches of color on the paper. The same mixture and the same kind of strokes are used to darken the distant mass of trees, which now have a more distinct feeling of light and shadow. You can see where a few dark trunks have been suggested among the distant trees—and a few light trunks have been scraped out with the tip of the brush handle.

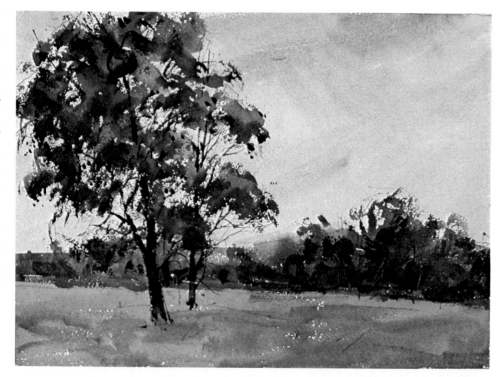

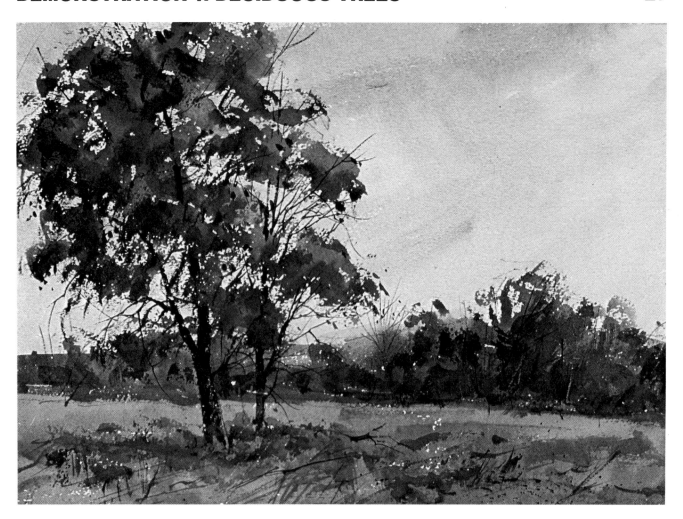

Step 7. The foreground is saved for the very end. A large brush is freely stroked across the field, sometimes depositing wet strokes and sometimes creating drybrush textures. These darks are mixtures of burnt sienna and Hooker's green. A small brush is used to build up small, rough strokes directly beneath the trees, suggesting shadows on the grass. More branches are added with the very tip of the small brush carrying a mixture of alizarin crimson and Hooker's green. A sharp blade scrapes away some flecks of light on the thicker treetrunk. The alizarin crimson and Hooker's green mixture is also used for the slender strokes that pick out individual weeds at the lower edge of the painting. Finally, a small, round brush is dipped in the alizarin crimson-Hooker's green mixture and flicked at the foreground, spattering droplets that you can see most distinctly in the lower right section. The foreground contains just enough texture and detail to suggest an intricate tangle of weeds and grasses—but not so much detail that it becomes distracting.

Step 1. The pencil drawing defines the main masses of the trees, but not too precisely—so there's plenty of freedom for impulsive brushwork later on. The sky begins with a very wet wash of yellow ochre, applied with a big, flat brush, followed by broad strokes of Payne's gray and ultramarine blue while the underlying wash is still wet. Just before the sky loses its shine, the distant trees are painted into the wetness with Hooker's green, Payne's gray, and cerulean blue, applied with a small brush.

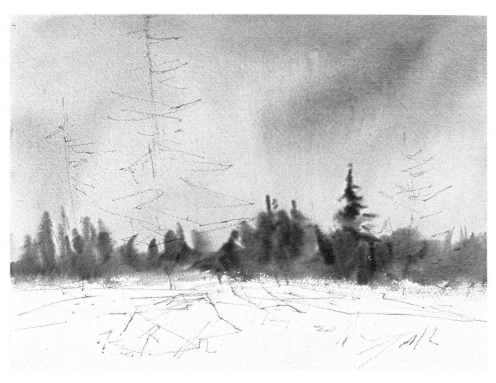

Step 2. When the sky and the distant trees are dry, two more trees are brushed in with a darker mixture of Hooker's green, Payne's gray, and cerulean blue, applied with a small, round brush. These trees strokes have a special character that reflects the way the brush is handled. The wet brush is pressed down hard at the center of the tree and then pulled quickly away to the side. Thus, the stroke is thick and dark at one end, but then tapers down to a thinner, more irregular shape as the brush moves outward.

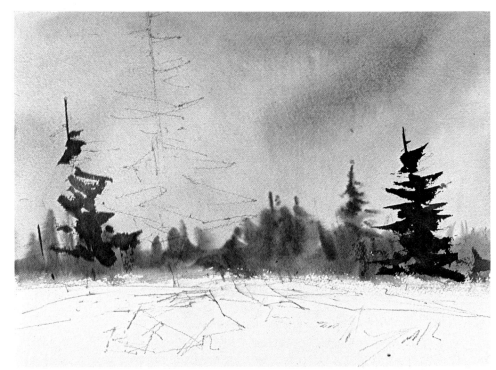

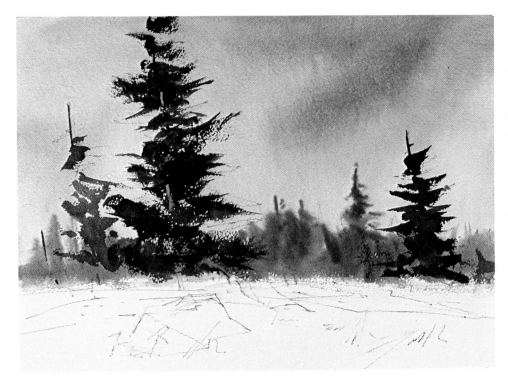

Step 3. The largest tree is now painted with a big, round brush, using the same kind of strokes as in Step 2. The lighter foliage is painted with Hooker's green, ultramarine blue, and burnt umber, then allowed to dry. The darks are painted with the same mixture, but contain more ultramarine blue. While the color is still damp, a blunt knife is used to scrape away some pale lines for the trunk.

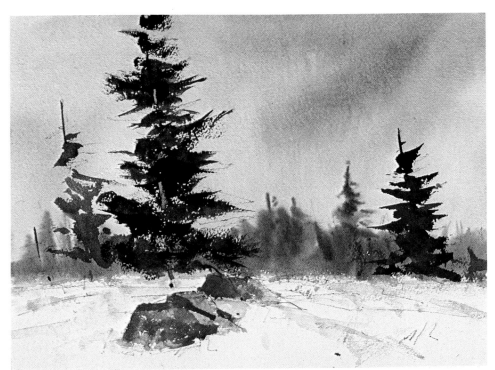

Step 4. The light and shadow planes of the rocks are both painted with Payne's gray and yellow ochre—with less water for the shadows. To suggest a few tones on the snow, a small brush glides quickly over the paper with pale strokes of ultramarine blue and burnt umber. Notice how flecks of paper are allowed to show through the shadows of the rocks, suggesting a rough texture.

Step 5. The dry grass breaking through the snow adds some warm notes to enliven a picture that is generally cool. The tip of a small, round brush is used to add drybrush strokes of cadmium orange, burnt sienna, and burnt umber. The same tone appears in the very slender strokes that suggest a few weeds—and is spattered across the foreground. These very thin strokes are a good opportunity to use the signpainter's brush called a rigger.

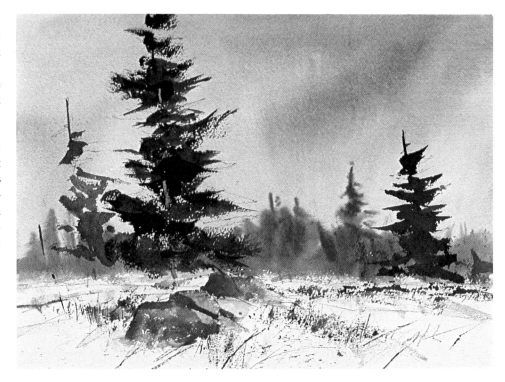

Step 6. The picture needs an additional tree to add "weight" at the center of interest. The tree is added with a dark mixture of Hooker's green, ultramarine blue, and burnt umber—using the same press-and-pull strokes that worked so well for the other trees.

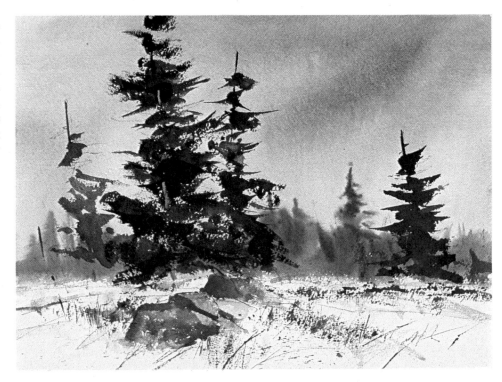

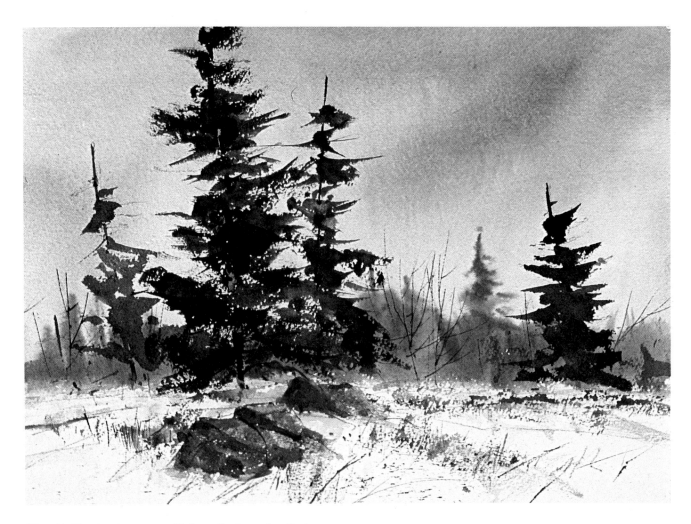

Step 7. Here's where you add those final touches that seem invisible at first glance, but do make a great difference when you look closely. A small, round brush is loaded with a dark mixture of alizarin crimson and Hooker's green. The very tip is used to add darks such as the trunks of the central trees, the cracks and additional touches of shadow on the rocks, and the skeletons of more trees along the horizon. A pale mixture of ultramarine blue and burnt umber is added just under the central tree to suggest a shadow that "anchors" the tree more firmly to the ground. Compare the finished trees and rocks with those in Step 6 and you'll see how much the picture gains by these slight touches. The big central tree is placed more firmly on the ground by its dark trunk and shadow. A few cracks and additional darks make the rocks much more solid and realistic.

Step 1. A meadow contains so much tangled detail that it's really impossible to do a very precise pencil drawing. So all you can do is indicate a few masses of light and dark, plus a few big weeds or branches and the shapes along the horizon. The slender band of sky is painted with overlapping strokes of yellow ochre and ultramarine blue, using a large, round brush.

Step 2. When the sky is dry, the darker tone of the distant hill is painted with a small, round brush loaded with cerulean blue and cadmium red. The lower edge of this band of color is softened and blurred with a stroke of clear water, applied while the color is still wet.

Step 3. When the hill is dry, the shapes of the distant trees are brushed over it with a small brush and a mixture of Hooker's green, burnt sienna, and cerulean blue. The strokes are quick, short, and sometimes applied with the side of the brush, giving a rough, irregular character to the trees. Once again, some of the lower edges are softened and blurred with a brushload of clear water.

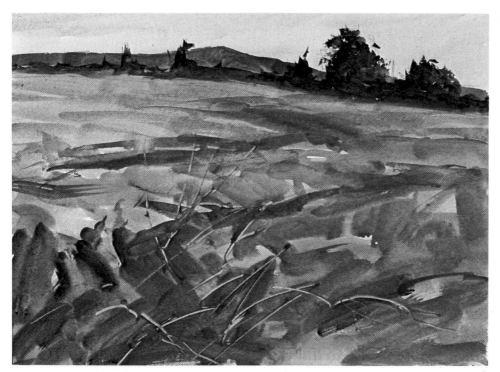

Step 4. Working with a big, round brush once again, the entire meadow is painted with casual, sweeping strokes that follow the curve of the landscape. The strokes are various mixtures of cadmium yellow, yellow ochre, Hooker's green, burnt sienna, and burnt umber—never more than three colors mixed for any one stroke. The lighter tones are added first and allowed to dry, then darker strokes are added in the foreground and allowed to blur into one another. Weeds are suggested by scratches of the brush handle or a fingernail.

Step 5. The color of the meadow needs to be strengthened. So the same mixtures are used to build up the darks of the foreground and also to darken the distant meadow, particularly in the upper left section. Do you remember how the dark bases of the trees in the upper right section were blurred with clear water? Now these trees seem to emerge softly from the meadow, growing out of their own shadows on the grass.

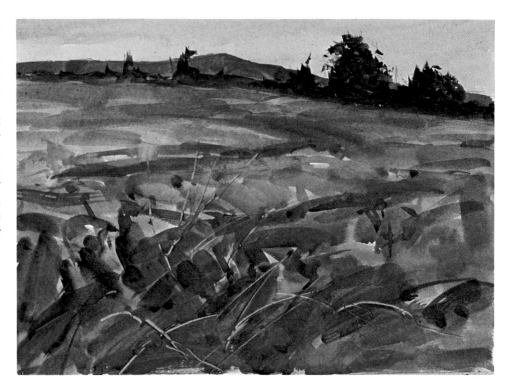

Step 6. The time has come to add some detail—very selectively. A dark mixture of alizarin crimson and Hooker's green is picked up by a small, round brush. The tip of the brush skates rapidly over the surface of the paper, suggesting twigs and blades of grass intertwined with the pale scratches made in Step 4. These details are concentrated in the foreground, not scattered over the entire field. A mixture of cadmium yellow and burnt umber is spattered among the twigs to suggest some wildflowers.

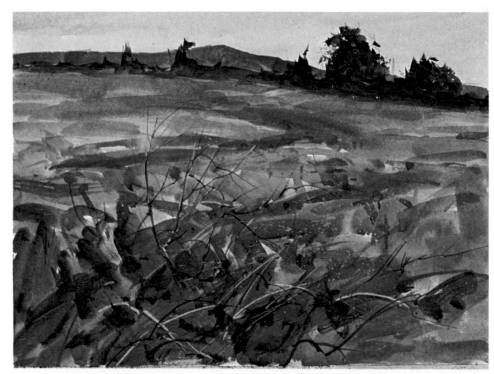

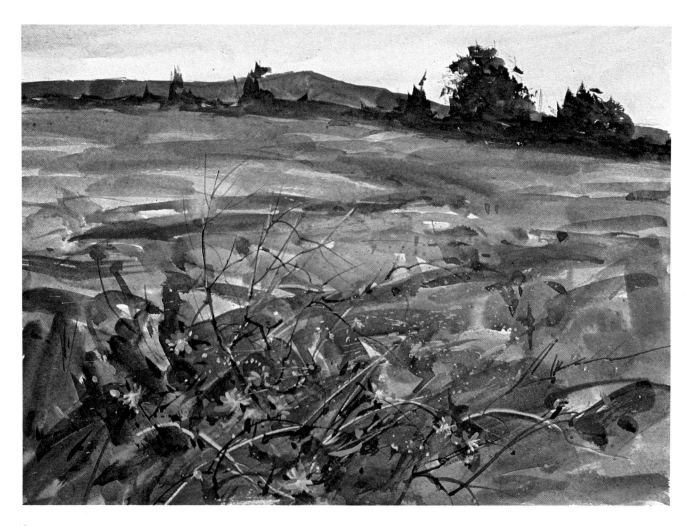

Step 7. The cluster of wildflowers is saved for the final stage. A new technique is introduced here. Because watercolor is transparent, you can't really paint pale flowers over a dark background. So this is one of those rare moments when you really need some *opaque* color. All you need is a tube of white acrylic color or a tube of Chinese white, as it's called. Mix a touch of this opaque white with your regular watercolors—preferably in a saucer or on some mixing surface that you keep away from your watercolor palette. The white will give your color just enough opacity to show up against the dark background. These flowers are mixtures of cadmium yellow, cadmium red, and alizarin crimson, with just a little opaque white. The paler strokes and the centers of the flowers obviously contain more white than the darker strokes. Only a few flowers are painted in detail. But more flowers are suggested by mere specks of color applied with the very tip of the brush. This is one of the most important lessons of landscape painting: if you have a certain amount of detail in the foreground, the viewer will imagine that the whole picture contains a lot more detail than he actually sees.

Step 1. The mountains have squarish, blocky shapes, perfect for painting with a big, flat brush. So the pencil drawing defines these shapes very clearly. The pencil lines also indicate the spiky shapes of the trees at the base of the mountains. The sky is first painted with a very pale wash of yellow ochre and cerulean blue. When this is dry, slightly darker strokes of this mixture, plus cadmium yellow, are painted over the pale background.

Step 2. The underlying pale tone of the mountains is blocked in with the broad strokes of a big, flat brush loaded with mixtures of yellow ochre, burnt sienna, and ultramarine blue. When this underlying tone is dry, the same brush is used to add darker strokes to the same mixture containing more ultramarine blue and burnt sienna. These strokes are allowed to dry and then still darker strokes are laid over them so that there is a gradual buildup of strokes from light to dark.

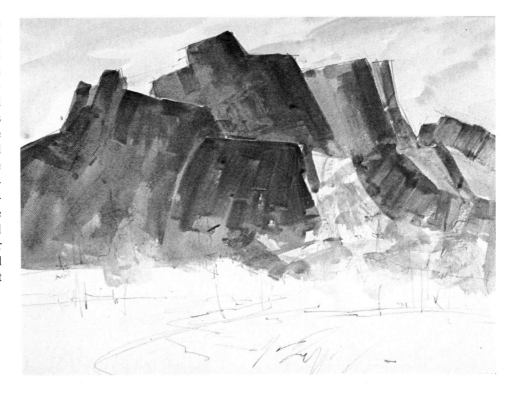

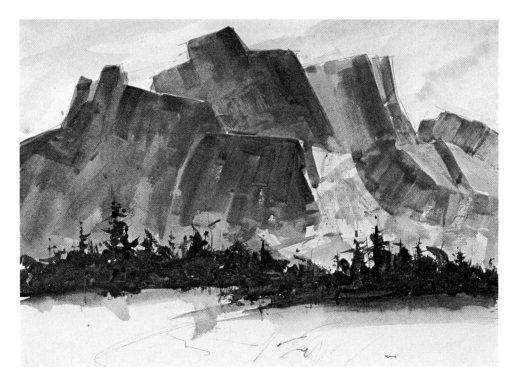

Step 3. A small, round brush works with quick, short, choppy strokes to paint the irregular line of trees at the base of the mountain. These strokes are a mixture of Hooker's green and burnt umber; there's no attempt to follow the original pencil drawing too precisely. Before this color dries, the lower edge is blurred by a stroke of pure water.

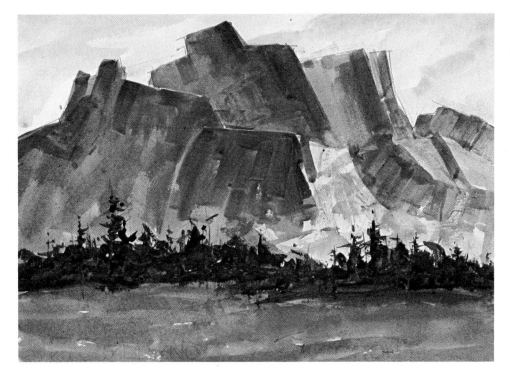

Step 4. The grass in the foreground is painted with horizontal strokes of mixtures of Hooker's green, burnt sienna, and cadmium orange. The strokes are brushed in very quickly and the surface is kept very wet, so one stroke fuses with another. Notice how the brushstrokes follow the forms in the painting. The mountains are straight, diagonal or near-vertical strokes. The foreground is painted with horizontal strokes, and the trees combine short horizontal and vertical strokes.

Step 5. The color of the mountains needs to be integrated more effectively with the rest of the picture; thus a cooler tone of cerulean blue and burnt sienna is brushed over them, darkening the bases of the mountains where they meet the row of trees. Now most of the mountains are clearly in shadow, dramatizing the sunstruck patch just to the right of center.

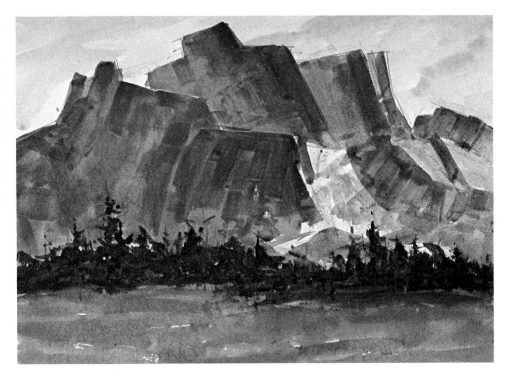

Step 6. Detail and texture are added to the foreground with a small, round brush. Quick, slender strokes are added with a mixture of burnt sienna and Hooker's green. The same mixture is spattered across the foreground. You now have the feeling that there are weeds and tufts of grass in the meadow.

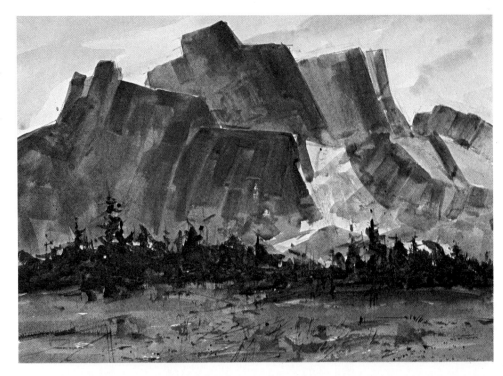

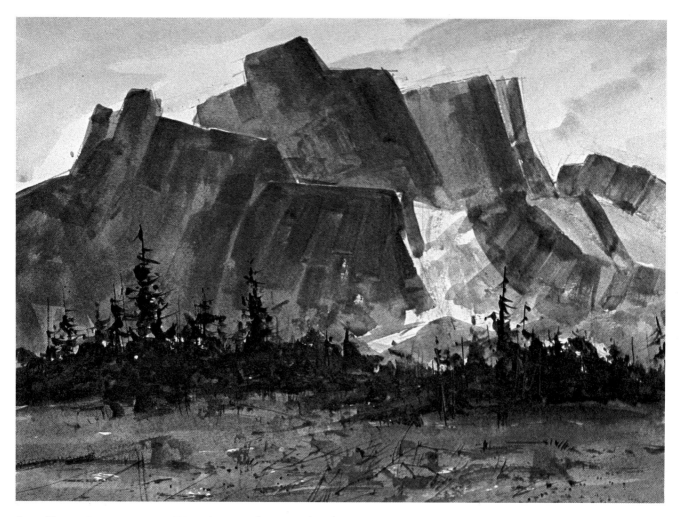

Step 7. The final step is to build up the row of trees so they seem closer, loftier, and more distinct. A dark mixture of Hooker's green and burnt umber is applied with the tip of a small brush, working in short vertical and horizontal strokes. These are the press-and-pull strokes used to paint the evergreens in an earlier demonstration. Some strokes are darker and some are lighter, creating the impression of lights and shadows among the trees. Because you now see the trees more clearly, they're closer to the foreground; by contrast, the mountains seem more distant. The picture gains a much deeper sense of space.

Step 1. The pencil drawing traces the shapes of the hill-tops very carefully; defines the curves within the hills and the lines of the shore; but simply suggests the trees, leaving room for free brushwork later on. The sky begins with a pale wash of yellow ochre, followed by strokes of Payne's gray, wet-in-wet. The distant hills are painted with Hooker's green, cerulean blue, and Payne's gray.

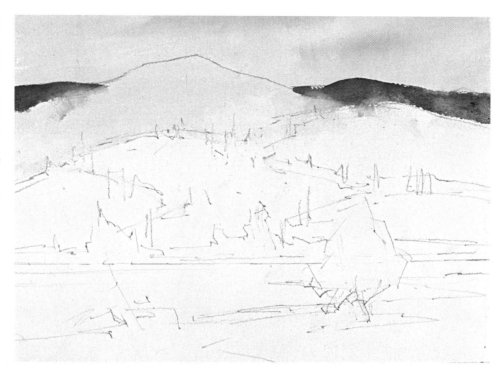

Step 2. The big shape of the hills is covered with a wash of Hooker's green, yellow ochre, and ultramarine blue. While the underlying color is still damp, darker strokes are added to suggest trees. These strokes are a mixture of Hooker's green, burnt sienna, and ultramarine blue, blurring slightly with the damp under-tone. When the entire area is dry, more trees are suggested with this dark mixture.

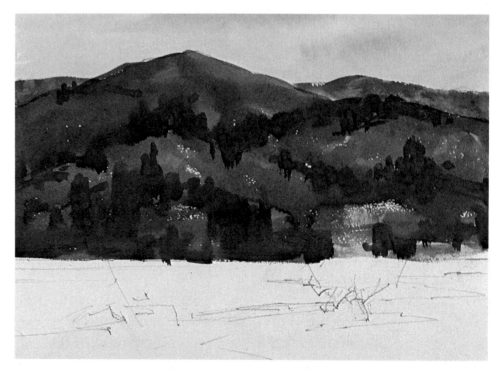

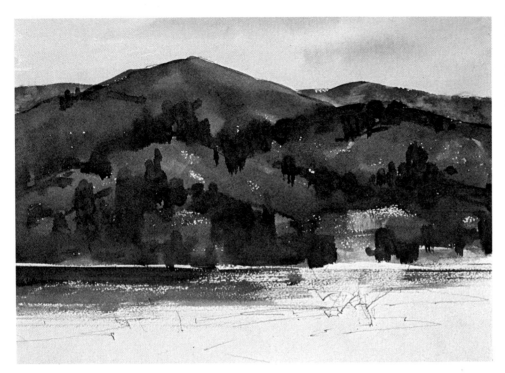

Step 3. To indicate the reflections in the water, a small, flat brush is loaded with Hooker's green, burnt umber, and ultramarine blue, then drawn across the paper with steady horizontal strokes. At the left, the color is heavy and fluid. At the right, the brush is merely damp, producing a drybrush effect that suggests light shining on the water. The light patches are bare paper.

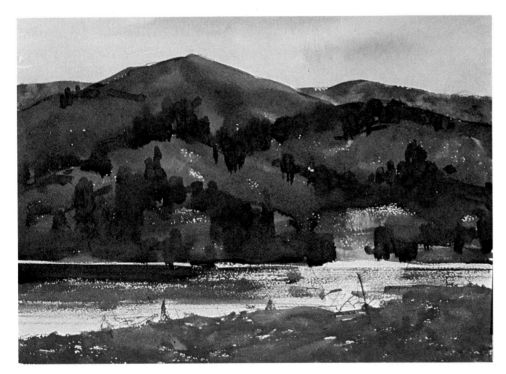

Step 4. The foreground is painted with mixtures of cadmium yellow, Hooker's green, and cadmium orange. The strokes are applied quickly, overlapping one another and flowing together. Here and there, you see touches of almost pure cadmium orange, which add some necessary warm notes to a cool picture.

Step 5. When the foreground color is dry, the tree and bushes are brushed in with a mixture of Hooker's green, burnt umber, and burnt sienna. The color is quite thick, containing just enough water to make it fluid, and the side of a small, round brush is used to create ragged, irregular strokes. A slightly paler version of this mixture—with more water—becomes the shadow under the tree.

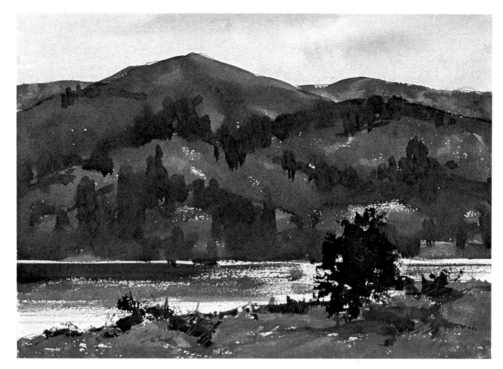

Step 6. The dark trees on the distant hill become slightly more distinct as a small, round brush adds strokes of burnt umber and Hooker's green. Some of these strokes are broad and chunky, suggesting the overall shape of a tree. Other strokes are vertical and slender, suggesting treetrunks. If you look closely, you're not really sure that you see any specific trees, but these additional dark strokes *suggest* enough to give you the feeling that the trees are really there. This same mixture is used to darken the reflection in the left side of the water.

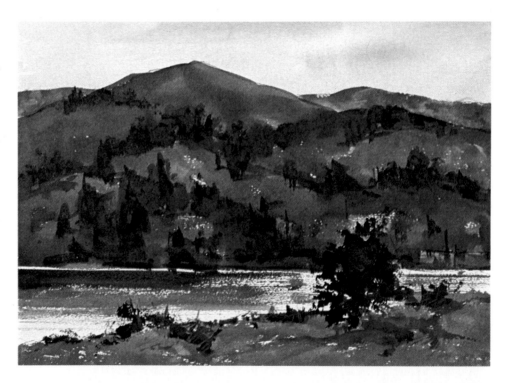

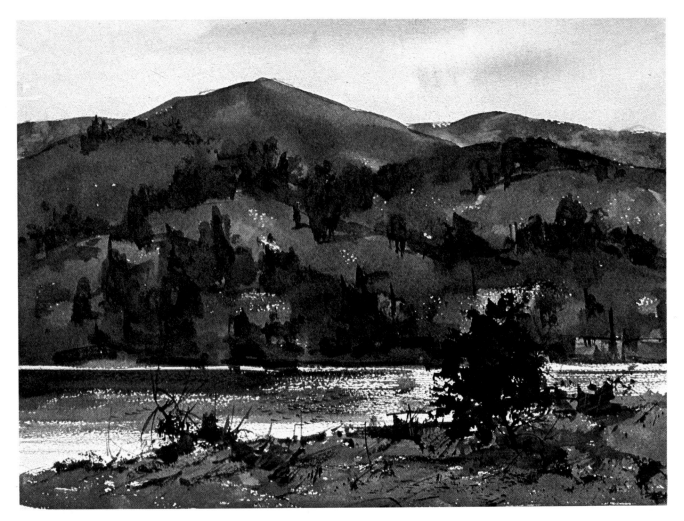

Step 7. Those last vital details are added to the grass and trees in the foreground. A small, round brush carries a mixture of alizarin crimson, Hooker's green, and burnt sienna. The tip of the brush adds a trunk and some branches to the large tree, some tangled branches to the bush in the lower left, and some slender lines to suggest twigs and weeds. You can also see more detail added to the water. A mixture of Hooker's green and burnt sienna is used to add some very tiny ripples in the water at the very center of the picture. You can also see additional drybrush work in the dark reflection under the hill at the left. The ripples don't cover the entire strip of water. There are just enough ripples to give you the feeling that the water is moving.

Step 1. Your pencil drawing can't possibly indicate every wave and ripple in the surface of the lake, so all you can do is draw a few lines to separate the dark areas from the light ones. And a few pencil lines can define the shapes along the shoreline. This sky starts with a wash of yellow ochre, which is allowed to dry. This is followed by some strokes of cerulean blue, modified by a hint of yellow ochre.

Step 2. The distant hills are painted with a wash of yellow ochre, Payne's gray, and cerulean blue. While the wash is still wet, it's blotted with a paper towel, which lightens the tone and fades it out in the right-hand side. Thus, the distant shore seems farther away and has a more atmospheric quality.

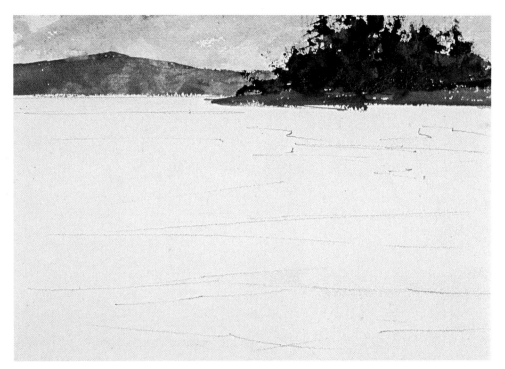

Step 3. As you can see, the whole idea is to work from top to bottom and from distance to middle distance to foreground. Now the tree-covered island is painted with strokes of Hooker's green and burnt umber. The strokes are short and rough, some darker and some lighter, some containing more Hooker's green and others containing more burnt umber. The color does not contain too much water, so the brush is damp, rather than wet, giving a ragged drybrush character to the strokes.

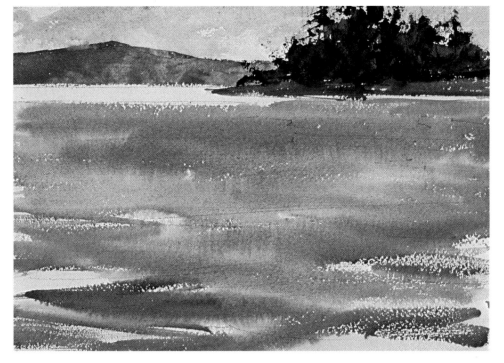

Step 4. The water is painted with a very wet wash that mingles yellow ochre, cerulean blue, ultramarine blue, and Hooker's green, all applied with a big, round brush. A pale wash of yellow ochre and cerulean blue goes onto the paper first, followed by darker mixtures that quickly spread and blur. In the foreground, you can see that the color isn't quite as fluid and the brush isn't nearly as wet, so the strokes at the very bottom of the picture are drybrush. The paint really looks wet—just like the water.

Step 5. When the colors of the water are dry, a small brush goes to work on the dark reflections under the island. These dark, horizontal drybrush strokes are a mixture of ultramarine blue, Hooker's green, and burnt umber. A few ripples and horizontal lines are drawn into the water with the tip of the brush. The dark patch in the upper left section is the same mixture, but with more water. Notice how the drybrush strokes in this section create the feeling that light is flashing on the ripples.

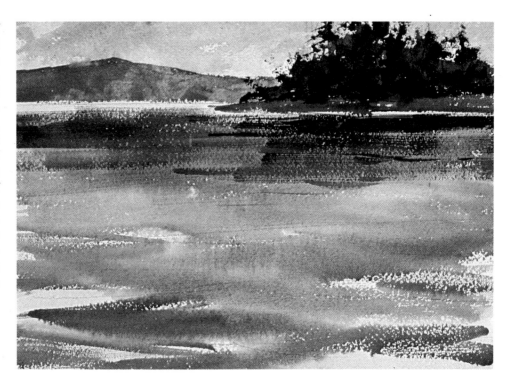

Step 6. Working downward, a small, round brush adds short, choppy, slightly curved strokes to suggest ripples. The strokes vary in length and thickness; thus they're never monotonous. The mixture is Hooker's green and ultramarine blue.

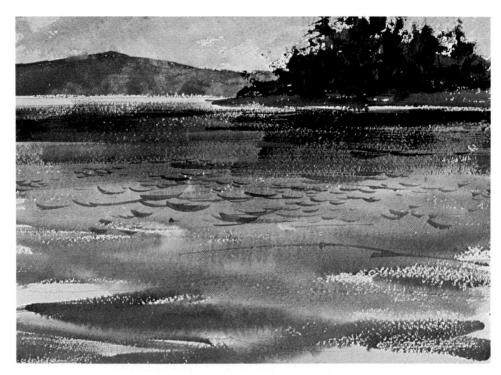

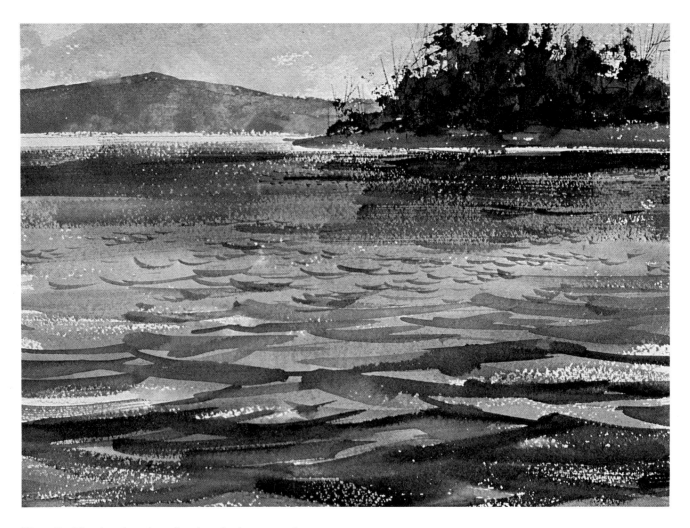

Step 7. The brushstrokes for the ripples grow longer, thicker, and darker as they approach the immediate foreground. The blend of Hooker's green and ultramarine blue is darkened by burnt umber. The smaller strokes are done with a small, round brush. Now the bigger strokes are executed by a large brush. Specks of white paper continue to peek through like sparkles of light on the water. Finally, a few branches and other details are added to the island with a mixture of burnt umber and Hooker's green.

Step 1. This painting contains so many elements that the composition is fairly complex and needs a careful pencil drawing to determine where everything goes. Thus, pencil lines locate the rocks, the fallen treetrunks, and the curving patterns of the water. The sky is a wash of yellow ochre, followed by strokes of cerulean blue applied while the underlying color is still wet.

Step 2. The mountain along the horizon is a wash of ultramarine blue, alizarin crimson, and yellow ochre. As you can see, the wash isn't absolutely smooth. At some points, there's more alizarin crimson, while there are other places where you can see more yellow ochre or more ultramarine blue. The lower edge of the wash is lightened and is slightly blurred by strokes of clear water.

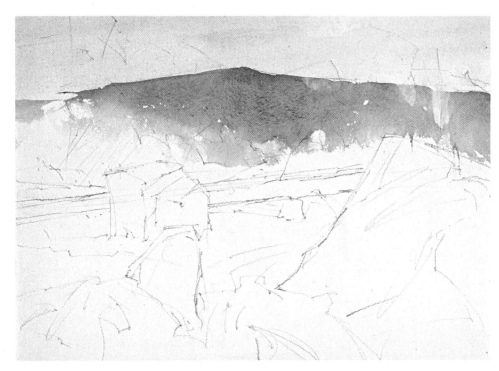

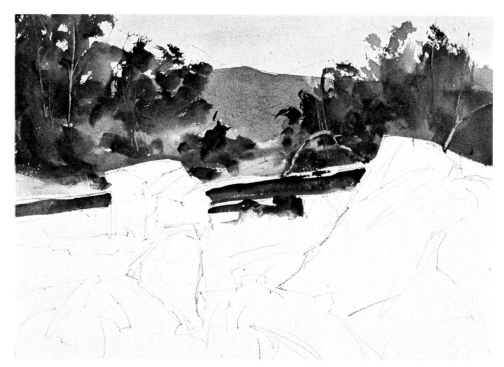

Step 3. Over the dried wash of the hills, the trees are painted with various combinations of cadmium yellow, yellow ochre, burnt umber, and Hooker's green. The lighter strokes, mainly yellow and green mixtures, go in first. Then, while the underlying strokes are still wet, the darker strokes go over them. Thus, the light and dark strokes tend to fuse. While the darks are still wet, some light trunks and branches are scraped out with a blunt knife. The dark treetrunk is painted with a blend of Hooker's green and alizarin crimson, and a bright patch of cadmium red is added while the dark tone is still wet.

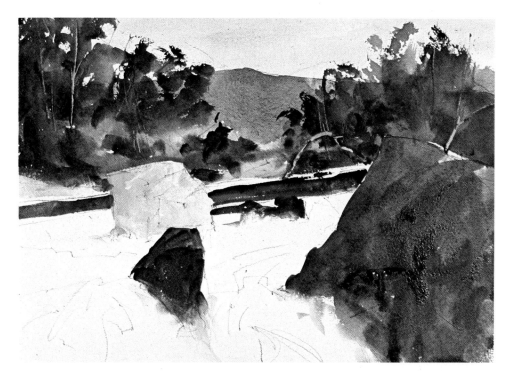

Step 4. The sunny rock is painted with fluid strokes of pure yellow ochre, blotted with a paper towel on the lighter side. The darker rocks are painted with ultramarine blue, burnt umber, and cerulean blue. Pale strokes come first, and then the dark ones are painted in while the underlying color is still wet. The lower edges of the rocks are blurred with clear water so that the solid forms seem to melt away into the running stream.

Step 5. Shadows of burnt sienna and cerulean blue are added to the sunlit rock. Then the shadows on the other rocks are deepened with ultramarine blue and burnt umber. This same mixture is used to add shadows to the distant trees with short, scrubby strokes. And the tip of a small brush adds some branches. You can also see some spatters of this mixture on the rock in the lower right.

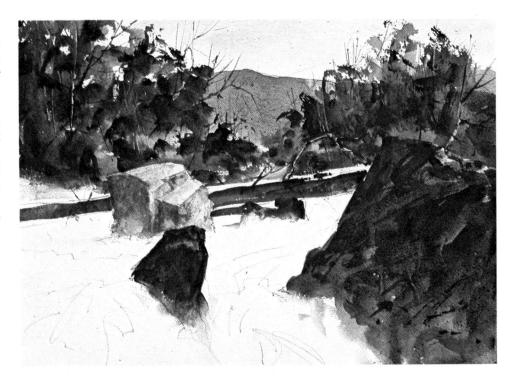

Step 6. Until now, the water area has been left as bare paper. Now the immediate foreground is covered with a very pale wash of yellow ochre, Hooker's green, and cerulean blue. While this area is still wet, the brush goes back in with dark strokes of Hooker's green and burnt umber that fuse with the underlying color, wet-in-wet. A paler version of this same mixture indicates the shadow under the fallen treetrunk. The central strip of water is still bare white paper.

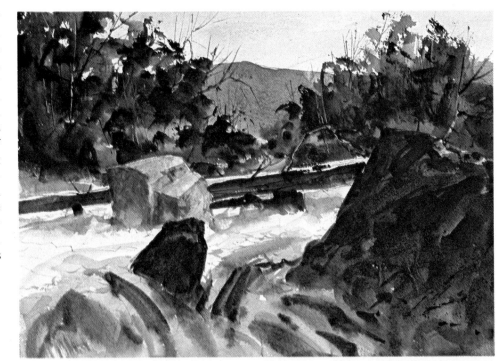

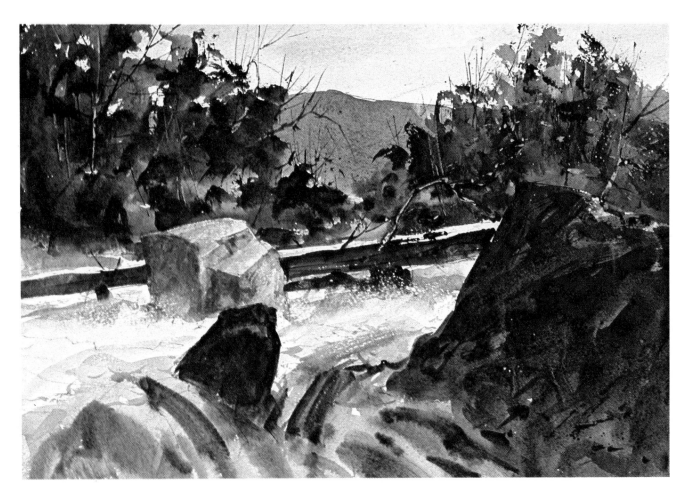

Step 7. A sharp blade is a wonderful tool for painting foam. Now the *edge* of a sharp knife or razor blade—not the tip—is lightly stroked across the area beneath the fallen trunk. The blade catches the high points of the paper and scrapes away just enough color to reveal tiny flecks of bare paper that look amazingly like foam. The knife also scrapes away a patch of light in the shadow side of the sunlit rock, so the shadow seems to contain some light reflected from the surface of the water. To enliven the trees to the right— and suggest some leaves caught in sunlight—a small, round brush spatters droplets of cadmium yellow. You can also see some small, pale strokes that suggest a few ripples in the water—a mixture of burnt umber, ultramarine blue, and a lot of water.

Step 1. A snow-covered field—which is, after all, simply water in another form—is just as difficult to draw as a lake. The best you can do is to draw the curves of the snowdrifts, the banks of the icy stream, the line of the horizon, and the shapes of the treetrunks. The sky begins as a pale wash of ultramarine blue and burnt sienna, followed by darker strokes of ultramarine blue and burnt umber, applied while the underlying color is still wet. While the sky is still damp, the distant trees are quickly put in with short strokes of burnt umber and Hooker's green.

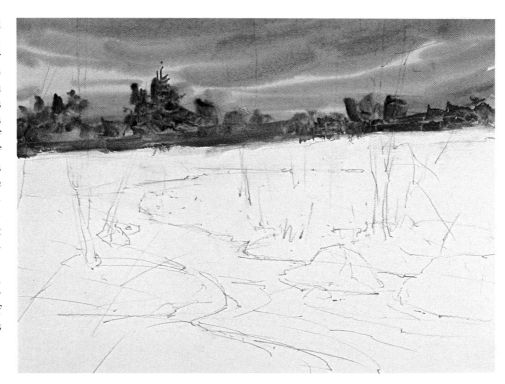

Step 2. The shadows on the snowbanks and the patches of tone on the snow are brushed in with a very pale mixture of cerulean blue and burnt sienna, and the shadows grow darker in the foreground area. Bare paper is left for the lightest areas.

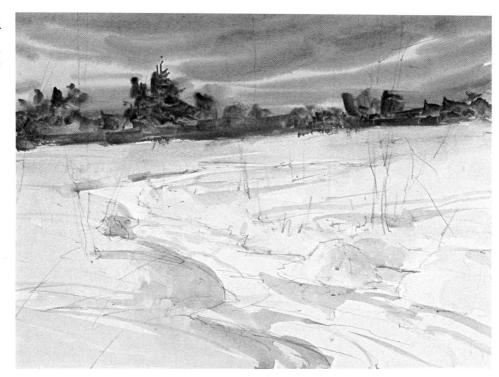

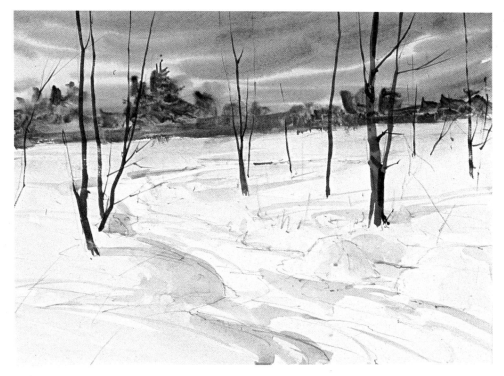

Step 3. The thickest, darkest treetrunks are added with very fluid strokes, a blend of alizarin crimson and Hooker's green. Look closely at the trunks—particularly the one on your right—and you'll see that the mixture is sometimes dominated by the green and sometimes by the red.

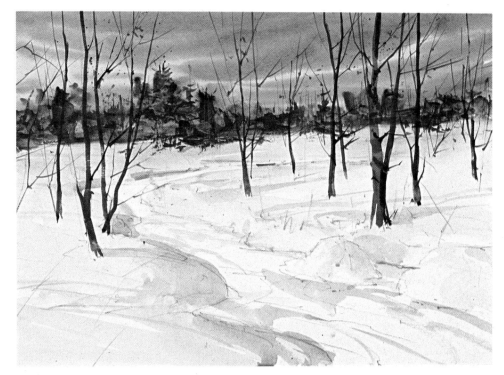

Step 4. More trees are added with the tip of a small, round brush carrying a mixture of Hooker's green and burnt umber. In the sky, you can see a light spatter of cadmium red, alizarin crimson, and Hooker's green, flicked on with the same brush. These dark droplets give you the idea that some dead leaves are still hanging from the slender branches. The distant trees are darkened with strokes of Hooker's green and burnt umber.

Step 5. The icy water, which reflects the dark tones of the sky and the surrounding trees, is now painted with curving strokes that wind from the foreground through the middle distance and back toward the horizon. The pale strokes come first; they are mixtures of Hooker's green and burnt sienna or Hooker's green and burnt umber. Then come the darker strokes, which are Hooker's green and alizarin crimson or cerulean blue and burnt umber.

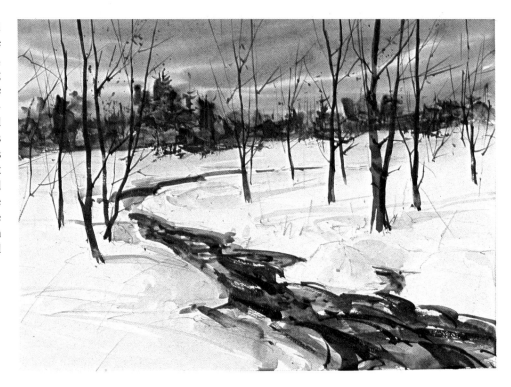

Step 6. Warmer touches are added along the banks, suggesting rocks. These are mixtures of burnt umber and cerulean blue. Touches of burnt sienna and cerulean blue are added among the treetrunks to suggest patches of dried weeds. The same mixtures are used for the thin strokes that render the stalks sticking up through the snow.

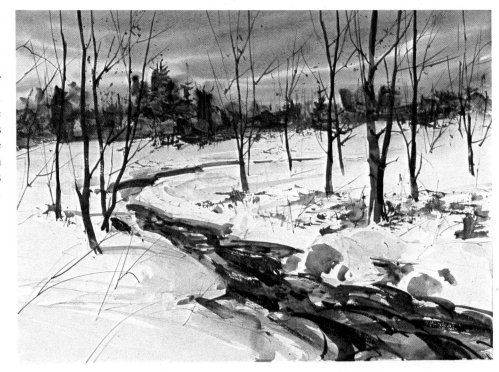

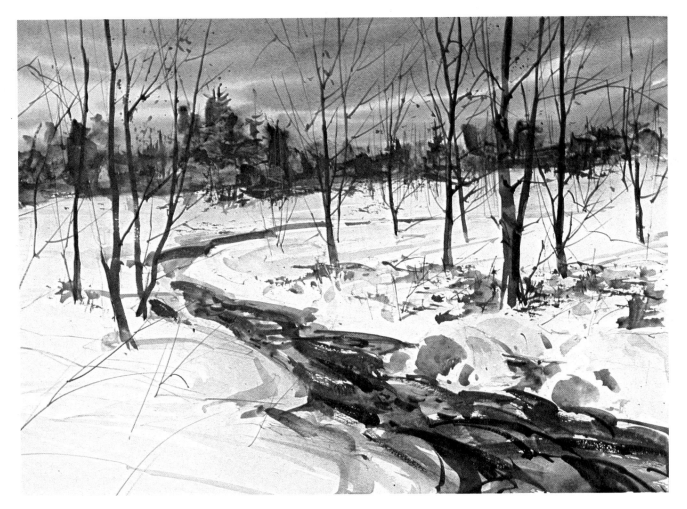

Step 7. In this final stage, the curves of the snowbanks—to the left of the frozen stream—are accentuated with curving strokes of cerulean blue and burnt sienna. This same mixture is used to add more touches of shadow beneath the trees on the right side of the stream. A few more touches of warm color—cadmium orange—enrich the dry grass among the trees. More darks and more branches are added to the tree-trunks with a mixture of alizarin crimson and Hooker's green. This snowy landscape shows how brushstrokes can mold the forms of the land. You've already seen how the direction of the strokes follows the frozen stream from the foreground into the distance. And you've noticed how the curving strokes in the foreground establish the rounded shapes of the snowbanks. But look carefully at the delicate streaks of shadow cast by the trees. These inconspicuous lines remind you that the snow isn't always flat, but sometimes has a slightly diagonal pitch, which you can see in the middle of the picture, and sometimes has a distinct roll, which you can see in the lower left section. These shadows function as *contour lines*, generally leading the eye over the curves and angles of the landscape.

Step 1. It's usually best to begin a sunny sky by painting in the blue patches between the clouds. The big blue shape in the upper left section comes first—a mixture of ultramarine blue, cerulean blue, and a little yellow ochre, touched with clear water to blur a few edges. The right side of the sky is brushed with clear water. Then more strokes of the same mixture are carried from left to right above the horizon, blurring as they strike the wet paper. The strip of blue at the horizon is also painted on wet paper, which produces very soft edges.

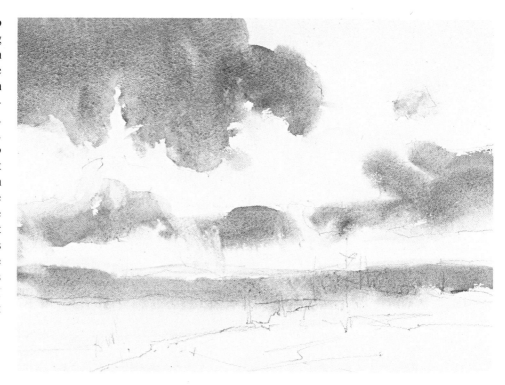

Step 2. When the blue areas are dry, the shadow sides of the clouds are brushed in with a pale wash of Payne's gray and yellow ochre. Once again, a brush carrying clear water is used to blur the edges of some of these strokes so that the shadows seem to melt away into the lighted areas of the clouds.

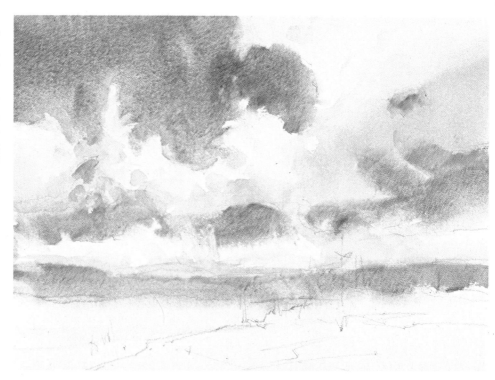

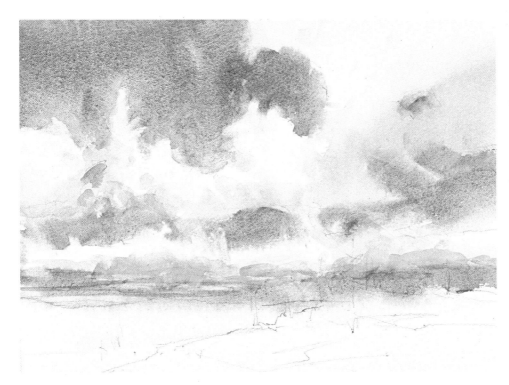

Step 3. When the shadows of the clouds are dry, more edges seem to need softening. A small bristle brush is loaded with water and used to scrub away color at various places where the edges of the clouds meet the edges of the blue sky. Then more strokes of Payne's gray and yellow ochre are added to suggest darker clouds along the horizon.

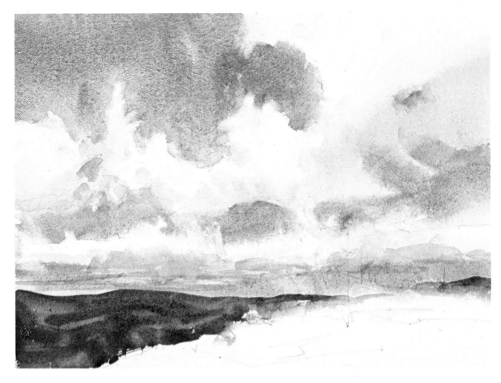

Step 4. When the sky tones are completely dry, the distant hills are painted with mixtures of ultramarine blue, cerulean blue, and burnt umber—with more burnt umber in the darker patches. Notice how strokes of clear water are used to soften some of the edges of the hills where they blend into the unpainted patch of foreground to the right.

Step 5. The hills are allowed to dry, and then the trees are painted with Hooker's green and burnt sienna, warmed here and there with a bit of cadmium red or cadmium orange. The lower masses of the trees are painted with broad strokes, while the upper trunks and branches are mere touches of the tip of the brush.

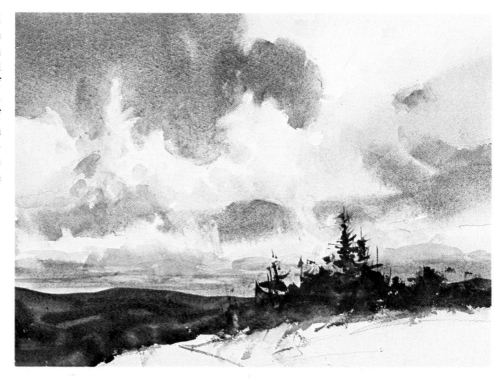

Step 6. The land in the foreground is painted with an irregular wash of Hooker's green, cadmium orange, and cadmium yellow. You can see that some areas contain more orange and some areas contain more green. A good deal of water is added in the lower right section; thus the wash becomes pale and suggests sunlight falling on the grass.

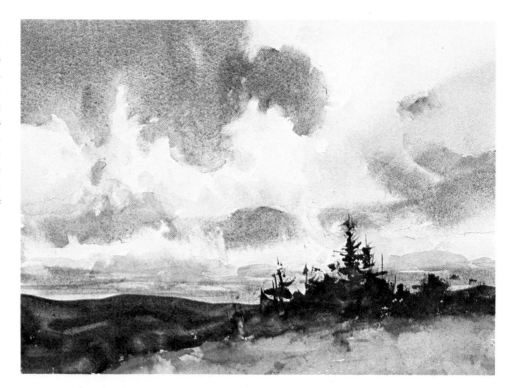

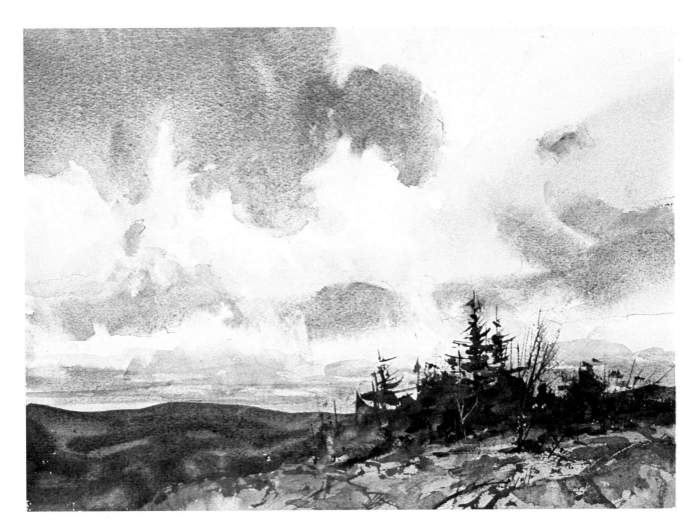

Step 7. The final touches of detail are concentrated entirely in the trees and grass in the immediate foreground. A dark blend of Hooker's green and burnt umber is used to add more detail to the trees—more trunks and branches and touches of shadow. You can see where a sharp blade is used to scratch out a light trunk beneath the tallest tree. The side of a small brush, loaded with Hooker's green and burnt sienna, is casually dragged across the grass to create darker patches. Then the tip of the brush picks up a darker mixture of Hooker's green and burnt sienna to trace some warm, ragged lines over the landscape. You don't actually see grasses, weeds, or twigs, but these strokes make you *believe* that you see them.

Step 1. Like most skies, a sunset is difficult to draw in pencil. Therefore, it's best to draw just the shapes of the landscape: the large tree to the right, the smaller trees along the horizon, and the lines of the stream. A large, flat brush is used to wet the entire sky with clear water. Then mixtures of yellow ochre, cadmium orange, burnt sienna, and cerulean blue are brushed onto the surface in long, slow strokes. The lights and darks and the warm and cool tones mingle, wet-in-wet. The sky is painted with the drawing board tilted slightly upward at the back so that the colors tend to run down.

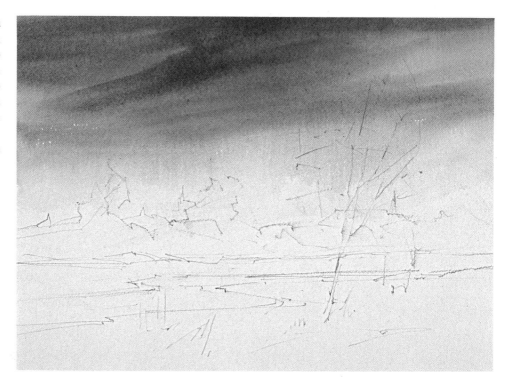

Step 2. When the sky is dry, the background trees are painted with mixtures of cadmium orange, burnt sienna, and Hooker's green. The warmer strokes are painted first and are dominated by burnt sienna. The darks contain more Hooker's green and are painted over the wet tones of the brighter colors. The ragged strokes against the sky are made by jabbing the brush against the paper, then pulling away.

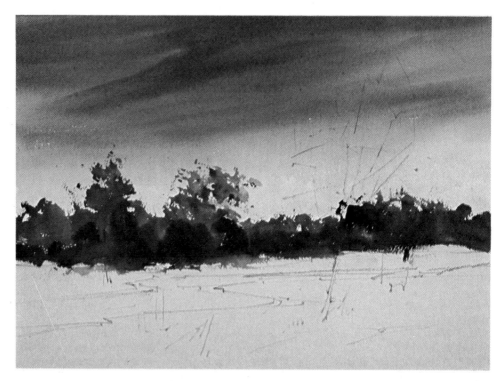

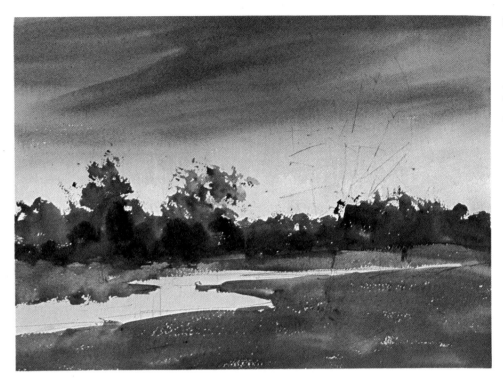

Step 3. The shapes of the land on either side of the stream are painted with mixtures of burnt sienna, Hooker's green, and cerulean blue. The immediate foreground contains more Hooker's green.

Step 4. Now the water is painted with a pale mixture of burnt sienna and cerulean blue. Notice that the strokes in the water are vertical, leaving gaps of bare paper, creating a sense of reflected darks and lights. The tone of the water is carried down over the shore to darken the left foreground.

Step 5. So far, the landscape is covered with generally warm tones—too warm to make a satisfying picture. The painting needs some strong, cool notes. The dark trees to the right are painted with short, rough strokes in a mixture of Hooker's green and burnt umber. The very ragged strokes against the sky are made by pressing the brush against the paper, pulling slightly to one side, and then pulling away. The lower tree is simply a dark, liquid mass that spreads at the bottom to suggest that it's sitting on its own shadow.

Step 6. The same mixture of burnt umber and Hooker's green is carried across the foreground with rough, irregular strokes, often made with the side of the brush. The underlying tones are allowed to break through here and there. Darker touches are added with the tip of the brush. Along the lower edge, to the right, you can see where droplets of dark color have been spattered into the wet wash. More of these darks are added to the distant trees with drybrush strokes.

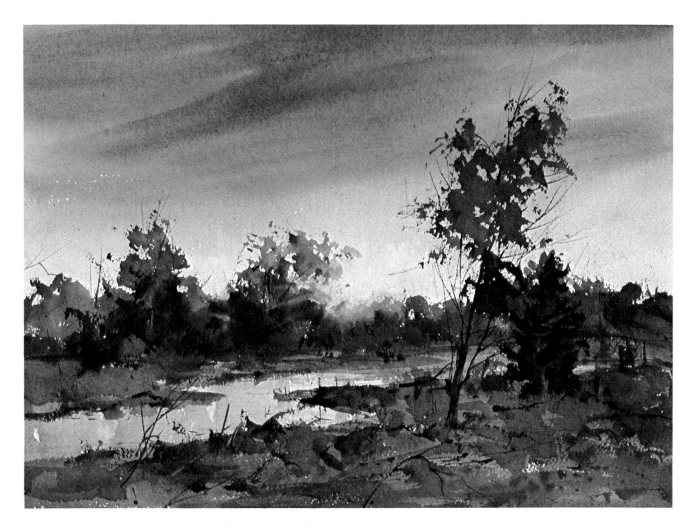

Step 7. Still darker strokes of the Hooker's green and burnt umber mixture are carried across the foreground with the tip of a small, round brush. More branches are added to the large tree, to the trees in the distance, and along the near shore. To suggest the glare of the sun going down behind the trees at the midpoint of the distant shore, a wet bristle brush is used to scrub out and soften the edges of the trees. When the color is loosened by the wet bristle brush, a paper towel is used to blot the area. The whole secret in painting a convincing sunset is *not* to overdo the hot colors. If you squint at the finished painting, you'll see that most of the colors are surprisingly dark and subdued. The whole lower half of the sky is extremely pale—just a hint of color to subdue the white paper. The only hot colors are in the upper sky, and even these bright streaks are intertwined with darker, cooler streaks. The sky looks bright precisely because it's surrounded by restrained colors.

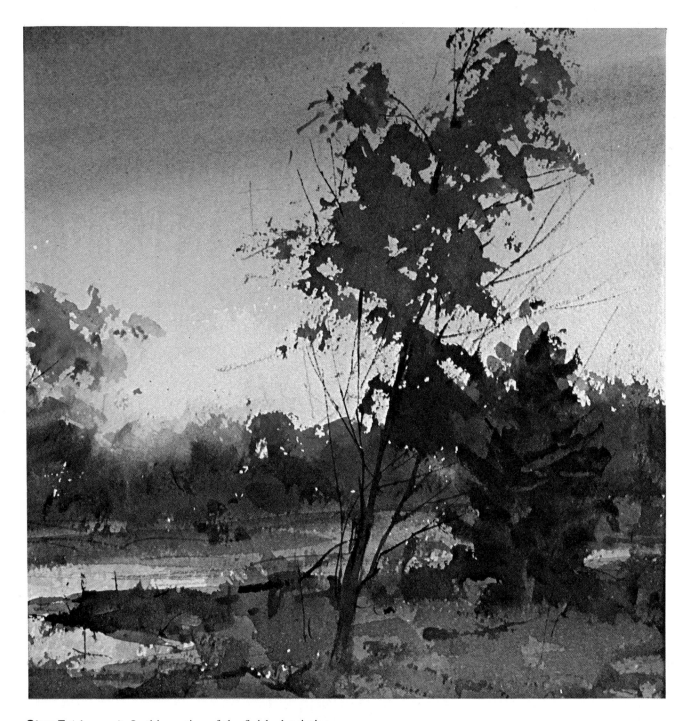

Step 7 (close-up). In this section of the finished painting, you can see the brushwork "life-size." The foliage against the sky is simply a series of flat silhouettes—patches of color without any detail. On the far shore, beside the tree at the left, it's easy to see where the tops of the lower trees have been scrubbed away to suggest the glare of the setting sun. In the sky above, the various stripes of wet color—which were brushed onto wet paper—fuse softly together.

Be Decisive. Beginning landscape painters often spend hours wandering about trying to discover the "perfect" landscape subject. By the time they find it—if they ever do—they're exhausted, and the painting day is half over. Given just so much time and energy, you'll produce a far better painting if you invest that time and energy in painting the first reasonably promising subject, even if it's not "perfect." In reality, nature almost never gives you a "perfect" picture anyhow. The professional painter knows this and always settles for an "imperfect" subject, which he transforms into a picture by moving around the trees, leaving out the smaller clouds, and adding some rocks that aren't even in the picture. So don't waste more than ten or fifteen minutes looking for your subject. As soon as you see something that *might* make a good picture, go to work.

Find Your Focal Point. Often, the simplest way to select a subject is to find some particular landscape element that appeals to you. It may just be an old tree, a few jagged rocks, a winding stream, or a hill against the sky. This motif isn't a picture in itself, but simply your center of interest, around which you *build* a picture. Once you've got your focal point or your center of interest, then you can orchestrate your picture around it. It's like writing a play around some famous performer. Now that you've got your star, you're ready to bring in the supporting cast. That old tree is probably surrounded by other trees, plus some grass, weeds, or rocks. You can now assemble a certain number of these around your center of interest to create a satisfying picture. In the same way, the dramatic shape of that hill against the sky isn't a picture in itself, but becomes the focal point of a picture when you include some surrounding hills, some trees in the foreground, and some sky above. Selecting the center of interest is just the *beginning*—but it's a good way to get started.

Contrast or Conflict. Another way to discover a subject is not to look for a single motif such as a tree or a hill, but to find some contrast or conflict within the landscape. You may just be intrigued by the contrast of dark trees against the white snow of a winter landscape; the clumsy, blocky forms of a rock formation amid the slender, graceful forms of weeds and wildflowers in a meadow; the long, low lines of the plains contrasting with the round, billowing forms of the clouds above. Of course, having found your subject, you still have to decide on your center of interest, so your painting has some focal point. Which are the

biggest trees, rocks, or clouds—or the ones with the most *interesting shapes*. If you can't *find* a center of interest ready-made, you'll have to *create* one by making it bigger or by exaggerating its odd shape.

Watch the Light. From dawn to dusk, the sun keeps moving, which means that the direction of the light keeps changing. At one moment, a subject may seem hopelessly dull. But an hour later, the light's coming from a slightly different direction, and that subject is transformed. At noon, those trees, rocks, or hills may not impress you at all because the sun is high in the sky, producing a bright, even light, with very few dramatic shadows. But in the late afternoon, with the sun low in the sky, creating strong shadows and interesting silhouettes, those dull trees, rocks, or hills may take on unexpected drama. Conversely, the delicate colors of those wildflowers may look brightest at midday and lose their fascination in late afternoon. So the key to finding a subject may be watching for the right time of day and the right light effect.

Keep It Simple. Knowing what to leave out (or take out) is just as important as deciding what to put into a painting. Nature offers you an infinite amount of detail and it's tempting to try to load it all into the picture. But you can't include everything. It makes the job of painting much harder and bewilders the viewer. Besides, watercolor doesn't lend itself to rendering a great deal of precise detail. Watercolor's a broad medium, and it's best for painting simple forms with broad strokes. So don't try to paint every treetrunk, branch, twig, and leaf in the forest. Pick out a few trunks and a few branches; try to paint the leaves as large masses of color. Don't try to paint every cloud in the sky, like a vast flock of sheep, but focus on a few large shapes, even if it means merging several small clouds into a big one—and simply leaving out a lot of others. Don't try to paint every rock on the beach; pick out a few large rocks for your center of interest, then include some smaller ones to make the big ones look bigger by contrast.

Using a Viewfinder. Many landscape painters use a very simple tool to help them decide what to paint. Take a piece of cardboard just a bit smaller than the page you're now reading. In the center of the cardboard, cut a "window" the same proportion as a half sheet of watercolor paper. Let's say 4″ × 6″ (100 mm × 150 mm). Hold this viewfinder at a convenient distance from your eye—not too close—and you'll quickly isolate all sorts of pictures within the landscape, far more pictures than you could paint in a day.

Don't place your center of interest in the dead center of the picture like a bull's-eye. And don't run the horizon straight across the middle so that it divides the picture into equal halves. This sort of symmetry makes a dull composition.

Do place the focal point of the picture off center. And place the horizon above or below the center. A good rule of thumb is to place the horizon about one-third of the way up from the bottom—as you see here—or one-third down from the top.

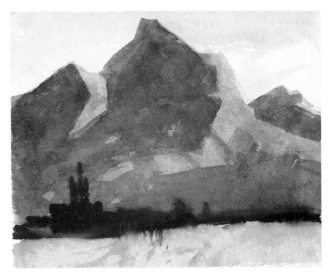

Don't make everything the same size and shape, such as these monotonous mountain peaks. Nor is it a good idea to space them out evenly, like a parade of soldiers.

Do vary the size and placement of the shapes in your painting. If you're working with three mountain peaks, make one really big, another one slightly smaller, and the third smaller still.

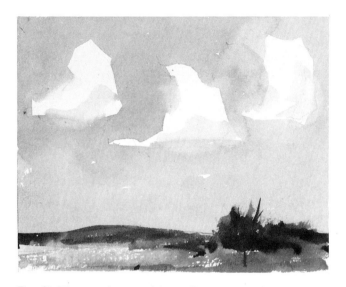

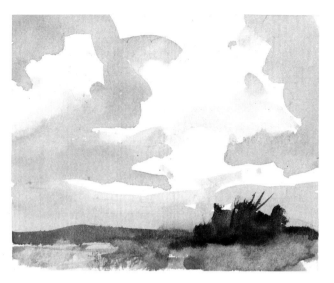

Don't fill your picture with small, scattered elements such as these tiny clouds floating in an empty sky. Like those monotonous mountain peaks, they're all about the same shape, with roughly equal spaces between them.

Do merge a couple of those small clouds into one big shape—or exaggerate one of them so that it becomes bigger. Balance the big cloud against the small one. Make the shapes of the two clouds as different as possible. And get rid of the third if you can't find a place for it.

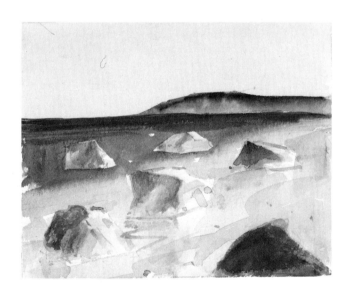

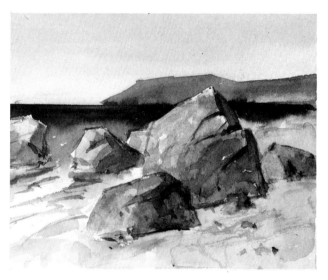

Don't scatter things across the landscape (such as these rocks) so the eye doesn't know where to look and can't find the focal point of the picture. The eye needs to know that there's one central character in the drama.

Do group those rocks, overlap them, make one really big, and make sure that the others are different sizes. Now the eye goes straight to the biggest shape. Naturally, these guidelines will apply not only to trees, peaks, clouds, and rocks, but to *any* landscape subject.

Tree in 3/4 Light. Before you begin to paint, study the subject, determine where the light is coming from, and get a clear idea of the pattern of lights and shadows. Here, the light is coming from the left side and slightly above the tree, throwing the right sides and the bottoms of the leafy masses into shadow. The tree also casts a shadow on the ground to the right.

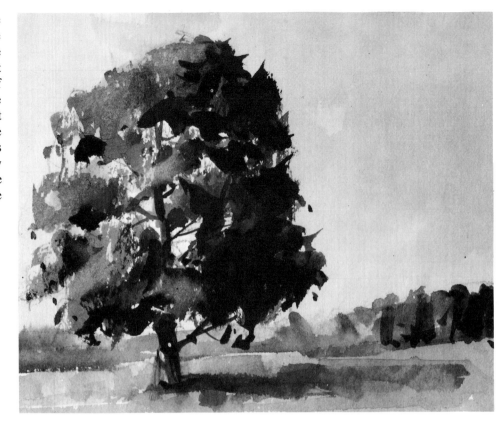

Tree in Back Light. Late in the day, when the sun is moving down toward the horizon, the light often hits things from behind and produces dark silhouettes. This back-lit tree consists entirely of dark masses, with no clear division between light and shadow. However, some of the leafy masses are a bit darker than others. Notice that the horizon is also just a dark, flat shape.

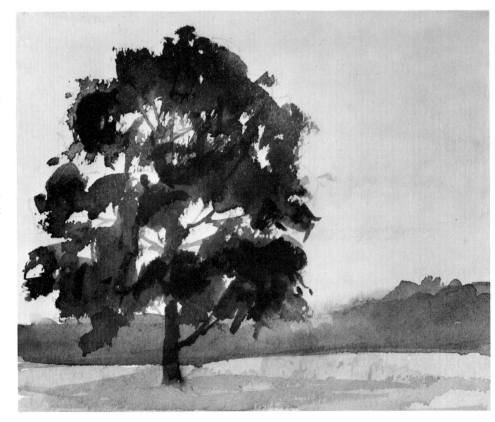

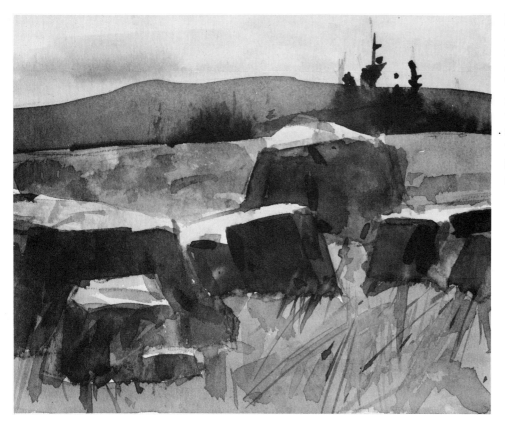

Rocks in Top Light. Around midday, the sun is directly overhead and shines down on the tops of things. Thus, the top planes of these rocks are in bright light, while the sides are in deep shadow. Try to visualize the trees on the preceding page in top light. And try to visualize these rocks in back light.

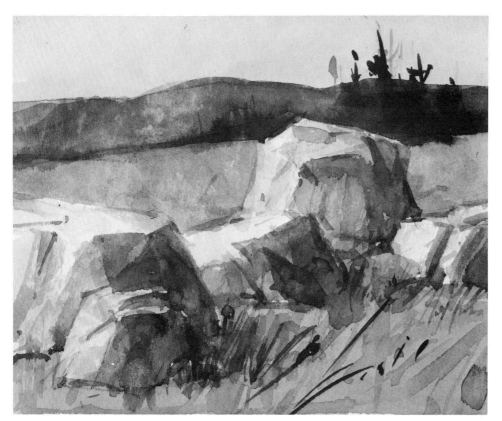

Rocks in 3/4 Light. These rocks, like the tree at the top of the facing page, are lit from the left and from slightly above. Thus, their tops and left sides are sunlit, while their right sides are in shadow. Notice that the shadows aren't quite as dark as those on the tree. That's because the light source isn't directly to the side, but just a bit in front of the rocks. It's just as important to define the direction of the light when you're painting *other* subjects, such as clouds, hills, and mountains.

Frontal Light. Exactly the same landscape can look quite different when the direction of the light changes. This snowy landscape is lit from the front. Imagine that you're facing the landscape and that the light is coming over your shoulder. Thus, the snow is pale and the distant sky is dark.

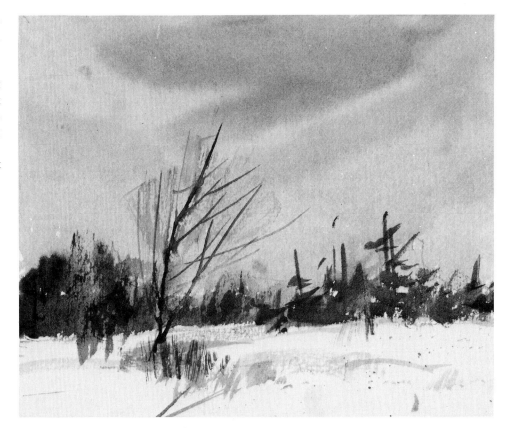

Back Light. Now the same landscape is lit from behind. The sun is sinking behind the distant trees, brightening the sky and throwing the snowy field into shadow. Decide which lighting effect you'd like to paint—or try them both.

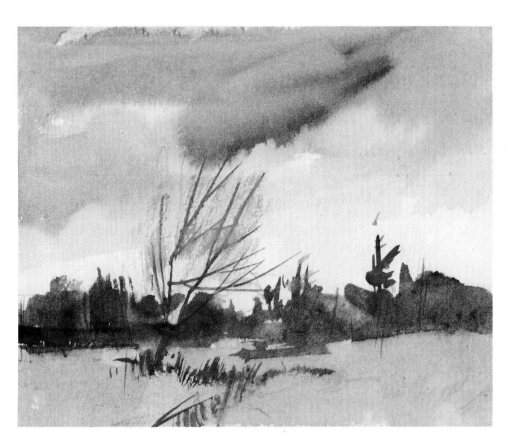

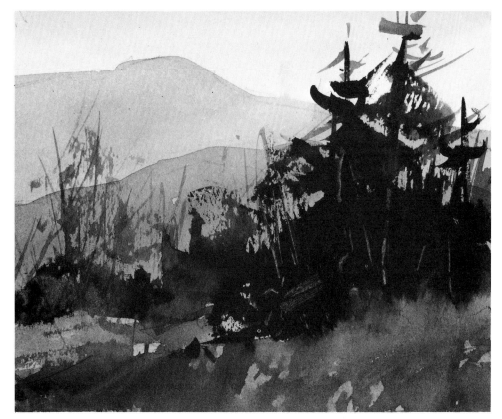

Mountainous Landscape.
Near objects tend to be the darkest and most detailed, such as the trees to the right. Objects in the middle distance tend to be paler and less detailed, such as the hill and the trees to the left. Far objects tend to be palest and contain the least detail. This phenomenon is called aerial perspective.

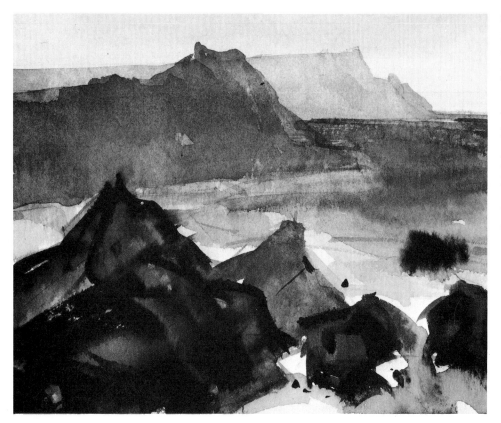

Coastal Landscape. The rocks in the foreground are darkest, and you can see lights and shadows on them. The headland beyond is just another big rock like those in the foreground, but it's paler—and the lights and shadows are less distinct. The headland on the horizon is paler still, and you can barely see any difference between the lights and shadows. By emphasizing aerial perspective, you'll give your landscapes a strong feeling of space and atmosphere.

Linear Strokes. A watercolor brush can make many different kinds of lines, depending upon which part of the brush you use—and how you hold it. If you work with just the tip of the brush, you can make rhythmic, slender lines. If you press down a bit harder, more of the brush will spread out onto the paper, and you'll produce thicker lines. That's how these treetrunks and branches are painted. The thick strokes of the branches are made by pressing down firmly so that not only the tip of the brush, but also a fair amount of the body, travels across the surface. For the thinner trunks, the brush isn't pressed down quite so hard. And just the tip of the brush is used for the slender branches and twigs. The brush carries lots of very fluid color. This group of trees is essentially a series of thick and thin lines.

Broad Strokes. If you work with the side of the brush, holding the wooden handle at an angle or almost parallel with the surface of the paper, you can make broad, ragged strokes like the brushwork used to paint these evergreens. The strokes will be particularly broad and ragged if you pull the brush sideways. That's how the thicker strokes in this picture were made. You can also press the brush firmly against the paper, pull it away to one side, and gradually lift the brush off the surface—making a stroke that starts out thick and ends up thin, like the brushwork toward the tops of these trees. Working with the side of the brush also gives you the broken drybrush textures you see along the edges of the branches.

ROCK FORMS

Blocky Forms. There's no such thing as a "typical" rock. Each has its own distinctive shape. The easiest rocks to paint are the ones that look like blocks. The tops and sides of these cubical forms are clearly defined; thus you can easily isolate the light and shadow planes. Most of the rocks in this picture have a brightly lighted top, a deep shadow plane on the right, and a middletone on the left.

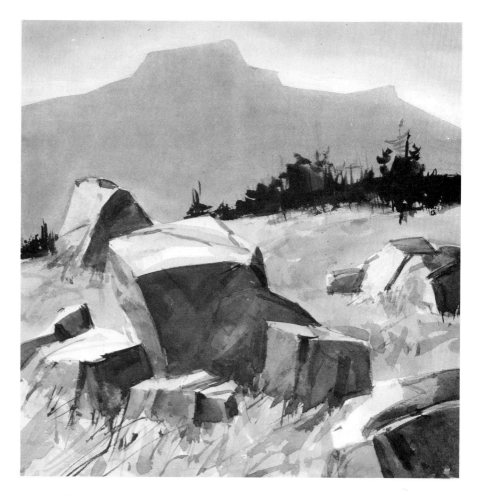

Rounded Forms. Another common geometrical form is the rounded rock, which looks like a sphere that's half buried in the earth. There's no distinct break between the light and shadow planes, but a gradual transition from light to dark. Here, the tops are brightly lit, and the sides that face you are in shadow. When you paint the shadow side, you can produce a soft transition by wetting the edge where the shadow melts into the light. You can see this clearly in the medium-size rock just below the center.

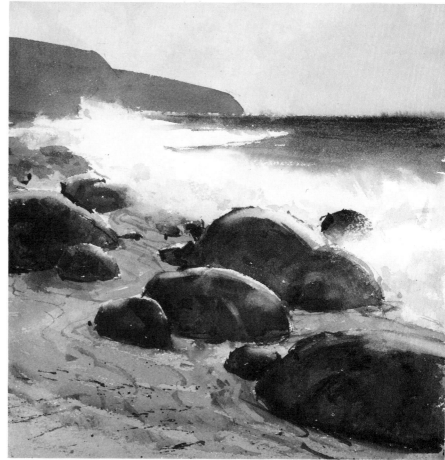

Horizontal Forms. Rocks often occur in horizontal strata, like a layer cake. The layers tend to form blocks; therefore you can paint the planes of light and shadow almost as easily as the blocky rocks on the facing page. And you'll need some lines to define the separate layers.

Vertical Forms. Tall rock formations often look like groups of columns or slender boxes stacked side by side. It helps to visualize them as tall, slender rectangles with light and shadow sides. You can render them very much the way you paint the layered rocks.

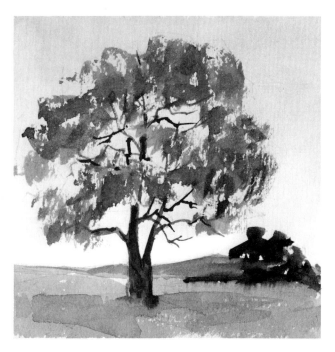

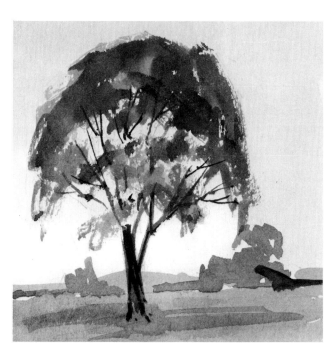

Oak. Every tree has its own distinctive silhouette, which you should try to visualize clearly before you paint. An oak has a broad, rounded shape, with big gaps between the bunches of leaves. You can see lots of sky and lots of branches in these gaps. The branches grow outward to the side.

Elm. A single domelike mass of leaves is typical of the elm. The branches grow upward and then turn slightly outward—but they never grow sideways like oak branches.

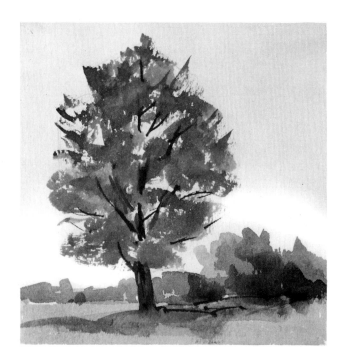

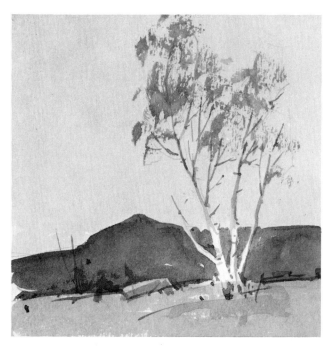

Maple. The leaves of the maple form dense, irregular clusters, among which the branches tend to be hidden. Naturally, the leaves are less dense in the spring, and you can see the branches more clearly.

Birch. Birches often appear in clumps, with multiple slender trunks that carry delicate, lacy leaves through which you can see lots of sky. Drybrush is a good technique for painting birch foliage. Not all birch trunks are as light as this one. There are also dark birches.

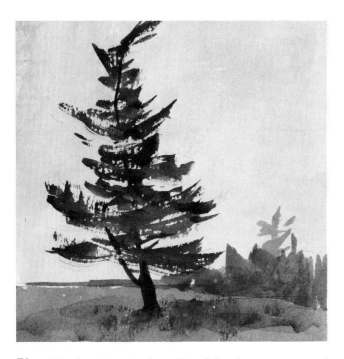

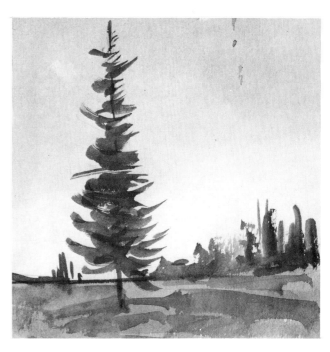

Pine. The densely packed needles of the pine grow outward in thick clusters that curve slightly upward. The silhouette is jagged and so are the shapes of sky that cut into the silhouette.

Spruce. The spruce looks somewhat like a pine at first glance, but the shape is narrower. The tree looks as if it would fit into a tall, slender cone. The masses of needles also form jagged shapes that turn upward at the end. It's hard to see the branches.

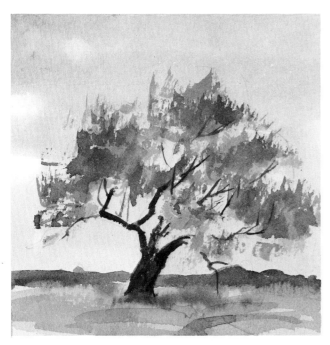

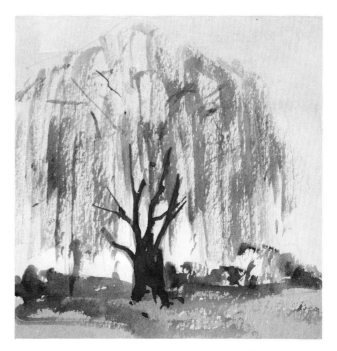

Apple. The apple tree is low, with a thick trunk and branches that often seem twisted and erratic. The tree may tilt to one side. The foliage forms irregular bunches that look lacy around the edges. There are big gaps of sky between the clusters of leaves.

Willow. The thick trunk and branches of the willow contrast with the very delicate, lacy leaves that trail downward like frothy, falling water.

Puffy Clouds. Clouds aren't mere blurs of smoke, but have distinctive, three-dimensional forms, often just as solid looking as rocks. Learn to identify the different cloud shapes, such as these cumulus clouds that are rounded at the top and generally flatter at the bottom, with clearly defined light and shadow sides.

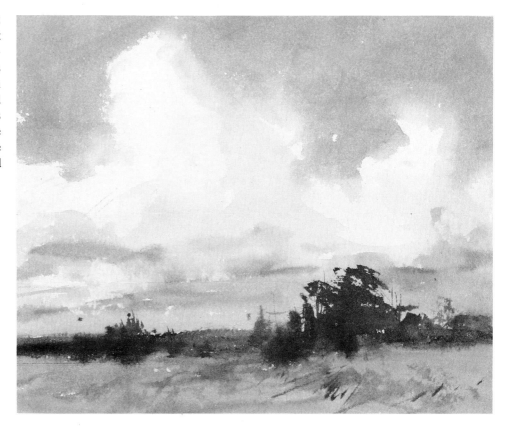

Layered Clouds. Not all clouds are round and puffy. They also occur in horizontal strata—one layer of clouds above another. It's often effective to paint such a sky wet-in-wet, as you see here. The paper is brushed with water and then the darks are brushed in with horizontal strokes. Be sure to leave light patches between. Notice that the layers are more tightly packed together at the horizon.

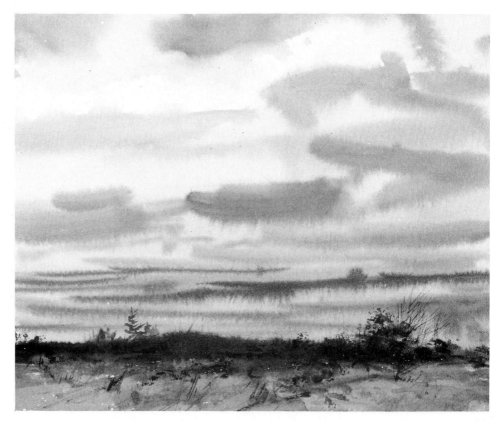

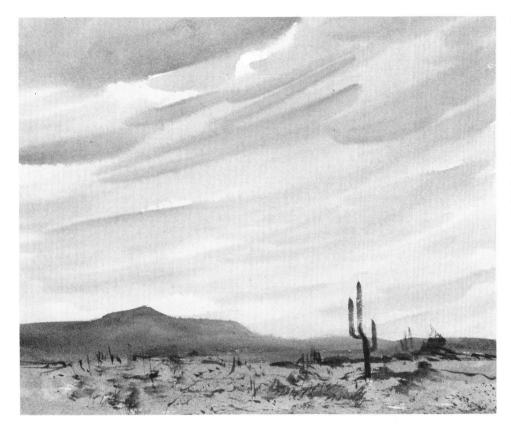

Windswept Clouds. The wind sometimes blows the clouds across the sky like laundry on a clothesline. The clouds curve and are blown upward at one end, somewhat like the layered clouds on the facing page, but with more movement. The clouds at the top are bigger because they're overhead. The clouds at the horizon are smaller because they're farther away.

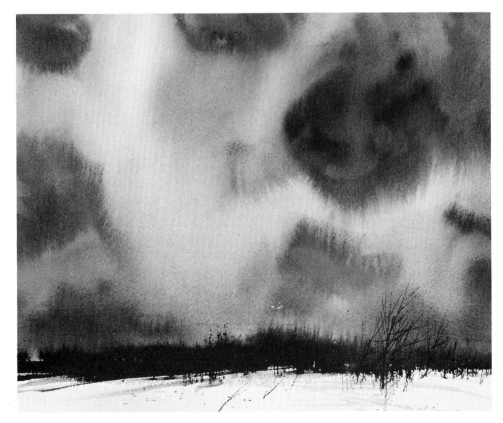

Storm Clouds. Because they roar in between you and the sun, storm clouds are frequently back lit. The sun is behind them, which is why they look dark. They have ragged edges because they're being blown across the sky by the stormy wind. This stormy sky is painted with lots of dark color on very wet paper.

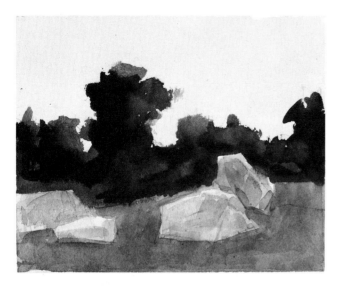

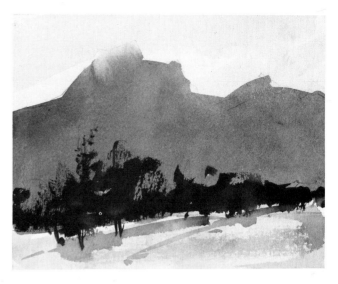

Rocks and Trees. When you plan a landscape, it's often helpful to visualize the picture in three distinct values—three different degrees of lightness or darkness—and perhaps a fourth value for the sky. Decide which is the darkest area, which is the middletone, and which is the lightest area. Here, the trees are obviously the darkest value; the ground is the middletone; and the rocks are the lighter shades. The sky is about the same tone as the rocks.

Mountainous Landscape. The lightest value is the snow in the foreground, which is repeated in the sky. The trees are the darkest value. The distant mountains are the middletone—repeated in the shadows under the trees.

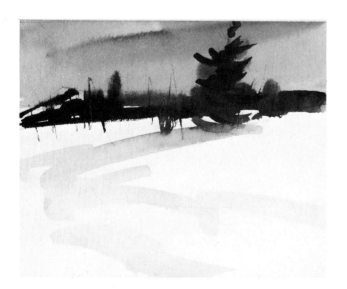

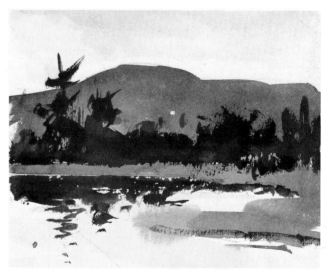

Snowy Landscape. Again, the snow is the lightest value and the trees are darkest. But now the sky is the middletone, and this middletone is repeated in the shadows on the snow. Before you start a painting, do some value sketches like these in order to plan the basic design.

Lake and Hills. The water mirrors the sky; together, they form the lightest value. The trees are darkest; this dark is repeated in their reflection. The land is the middletone. Naturally, such a sketch is a highly simplified version of the painting. It just helps you plan your washes, which will contain far more detail when you finish the painting.